VISUAL QUICKSTART GUIDE

PHOTODEX
PROSHOW

Jon Canfield

 Peachpit Press

Visual QuickPro Guide
Photodex ProShow
Jon Canfield

Peachpit Press
1249 Eighth Street
Berkeley, CA 94710
510/524-2178
510/524-2221 (fax)

Find us on the Web at www.peachpit.com.
To report errors, please send a note to errata@peachpit.com.
Peachpit Press is a division of Pearson Education.

Acquisitions Editor: Ted Waitt
Project Editor: Valerie Witte
Production Editor: Lisa Brazieal
Technical Editor: Evan Sutton
Copyeditor: Kim Wimpsett
Proofreader: Elissa Rabellino
Composition: Myrna Vladic
Indexer: Rebecca Plunkett

ISBN-13: 978-0-321-60618-1
ISBN-10: 0-321-60618-3

9 8 7 6 5 4 3 2 1

Printed and bound in the United States of America

Dedication:

To my Dad, Wayne. You're an inspiration to everyone who knows you, but especially to me.

Acknowledgments

Books are funny things. Although my name is on the cover, so many more people are involved in the creation of a book than the author. In some ways, I think I play a small role.

A large part of the credit for the finished product goes to those people behind the scenes. My editor, Valerie Witte, kept me on track and focused throughout the project, in spite of my best efforts to get distracted by other things. My tech editor, Evan Sutton, did a fantastic job of verifying that the information you're about to read is accurate. You can be assured that any errors still in this book are of my own making. I'd also like to thank Kim Wimpsett and Lisa Brazieal for their part in editing the text you see here and give a special thank you to Ted Waitt for making this whole project possible.

A special thank you goes out to Amanda Sahliyeh and Photodex for the assistance and information they provided during the project.

Finally, and most importantly, I want to thank my wife, Kathy. My best friend and partner for 30 years now, she never fails to inspire and support me regardless of the project or the impact on our time together.

CONTENTS AT A GLANCE

CONTENTS AT A GLANCE

TABLE OF CONTENTS

AN INTRODUCTION TO PROSHOW

Photodex ProShow is now in its fourth major revision. With each version, more features have been added, making an already powerful program even more useful.

Of course, all that power isn't much use to you if you're just starting out and don't know how to put a show together. Forget all of the fancy blending of images, synchronized music, and captions. Your initial goal may be just to put together a simple project that you can be proud of.

That task is much easier than you might have ever imagined. ProShow has everything a professional photographer could wish for, but it still makes it easy to create a complete show in just a few clicks of the mouse button. And when you're ready, ProShow can take you through the process from start to finish, enabling you to transform your slide shows into a masterpiece that will wow your viewers.

The Basics of Digital Slide Shows

Do you remember the old vacation slide shows you sat through (and, if you're willing to confess, made yourself)? Getting slides in the right order—facing the right direction and orientation so that you didn't leave Grandma standing on her head or force your viewers to read signs with reversed text—and then loading the slide projector without dropping the whole lot was often more than enough to keep your slides from ever being viewed!

Creating something professional looking—with transitions, music, and more—was beyond the capabilities of almost everyone but a professional, and it involved multiple projectors, stereo systems, and complex fade and mix equipment.

Today, that's thankfully all in the past. With digital images and ProShow, you can create something that exceeds even the most complex slide shows of the past, and you can do it in a fraction of the time. What's more, you can share that show with anyone you want, around the world. You don't need to synchronize busy schedules to gather in the living room for a viewing; simply send a DVD or even a Blu-ray Disc DVD, or post the show online.

Slide shows don't have to include just images either. You can add music soundtracks that are synchronized to the images and even insert video clips into your shows to increase the visual interest. If you're using ProShow Producer, you can also embed links for e-mail or Web sites into a show, making it easy to use your show as a tool to generate new business. Whether you choose to add these features to your show is completely up to you. The important point is that you *can* do it, and ProShow makes it easier to do than with any other program, regardless of price.

It's All About the Content

Don't let the ease of creation give you the wrong impression, though. A poorly designed slide show will still leave your viewers wishing they were doing anything other than watching a show where you decided to use everything ProShow has to offer just because you could. In addition, you don't want to end up with a distracting assortment of images and effects that don't bring all the elements together effectively, leaving your audience wondering exactly what it was they were supposed to be seeing. The more care you put into selecting your images and choosing the appropriate transitions and music, the more compelling your show will be.

Before you begin assembling your content, you should consider who your audience is and plan the show around who will be watching it. Some shows are meant to be seen and appreciated by family members only—little Junior growing up, for instance. Others, such as a show featuring a particular event or place, might be seen by countless people around the world, thanks to the Internet and Web sites such as YouTube.

For a family show, or any show tailored to a more general audience, you'll want to focus on images that tell a story and move at a comfortable pace to keep viewer interest high. For a show designed for a more technical audience—for example, a show on flowers that would be seen by a horticulture club—you'll want to slow things down and concentrate on the elements you're trying to teach. One good example is a show on the evolution of a particular type of plant. You might start with an overview of the plant species and some sample images, and then go into a detailed show with slides illustrating the different phases of the plant—details perhaps boring to someone who isn't technically inclined toward the subject but fascinating to the group who will be viewing this.

I'll cover how to add content to your show in Chapter 2, but it's not too early to start thinking about what you want to present. If you're at all like most digital photographers, you have thousands of images from which to choose. That doesn't make them all worth adding to a show, though! Give careful consideration to not only what goes into your show but also how you present it to your viewers. A good show will always have a logical start and finish. Your start should set the viewers up for what they'll be seeing. Often, this takes the shape of a title slide with text and perhaps a background image. The main portion of the show should be grouped into similar categories of imagery, whether the organization is based on a timeline or on subject matter. Finally, the show shouldn't conclude with just an abrupt stop to the music and images but rather should gradually wind down, leaving your viewers feeling that they've seen it all, yet wanting more.

To view a couple of examples of shows that follow these guidelines, check out the companion Web site, www.proshowbook.com, and click the Chapter 1 button. The examples will give you a taste for the types of shows that are possible with this amazing program.

It's All About the Content

Table i.1

ProShow Version Differences		
WORKFLOW AND USER INTERFACE	GOLD	PRODUCER
Add slides with drag and drop	X	X
Real-time preview	X	X
Integrated photo browser	X	X
Light box view	X	X
Manual show control		X
Custom keyboard control		X
Built-in audio trimmer	X	X
Built-in video trimmer	X	X
Find missing files utility	X	X
Back up collected show files	X	X
Slide options hotkeys	X	X
Favorites pane	X	X
Copy settings feature	X	X
Resizable slide previews	X	X
Slide preview grid	X	X
Hot folder/live show support		X
Interactive waveform in timeline	X	X
Timeline view	X	X
Notes	X	X
Set name for layer	X	X
Display time as seconds in timeline	X	X
Lock slide timings	X	X
New Audio Sync dialog	X	X
Show relative show time in audio trimmer	X	X
IMAGE/VIDEO OPTIONS		
RAW file support		X
Animated GIF support	X	X
Enhanced audio controls for video clips	X	X
Adjustment layers		X
Modifiers		X
Unlimited layers per slide	X	X
Loop video clip		X
Set video clip speed		X
Set end-of-slide action		X
Gradient as layer		X
Solid color as layer		X
Masking		X
Opacity settings for photos and videos		X
Transparency support for PSD, PNG, TIFF, and GIF	X	X

(table continues on next page)

ProShow Gold Versus ProShow Producer

One of the advantages to using ProShow is the consistent user interface in each version. And with the release of version 4, ProShow is now available in two forms, Gold and Producer (ProShow Standard is no longer being offered). You can start out with ProShow Gold and progress up to ProShow Producer without having to learn an entirely new program or way of working. Just apply what you've already learned and begin to take advantage of the new features immediately.

For a quick comparison of the versions, you can review **Table i.1**, which lists the different features available in ProShow Gold and ProShow Producer.

PROSHOW GOLD VERSUS PROSHOW PRODUCER

Table i.1 *continued*

ProShow Version Differences

IMAGE/VIDEO OPTIONS	GOLD	PRODUCER
Gradient backgrounds		X
EDITING		
Apply outline or drop shadow to layers	X	X
Control drop shadow color and opacity		X
Control layer outline size		X
Chroma key transparency		X
Vignettes		X
Red-eye removal	X	X
Rotate and crop photos	X	X
Rotate and crop videos	X	X
Color-correction	X	X
Adjustment effects keyframing		X
Keyframe editor		X
CAPTION EFFECTS AND OPTIONS		
Add multiple captions to a slide	X	X
Add global show captions	X	X
Control color, font, and size of captions	X	X
Expanded set of 100+ caption motion effects	X	X
Caption timing control		X
Caption interactivity		X
Caption keyframing		X
Use textures in captions		X
Use gradients in captions		X
Caption styles		X
Caption line/character spacing		X
Caption rotation		X
Character skew		X
MOTION EFFECTS AND TRANSITIONS		
Slide styles	X	X
Add motion effects to photos and videos (pan, zoom, and rotate)	X	X
More than 280 transitions	X	X
Specify random transition effects usage	X	X
Customize transitions per layer within a slide		X
One-click randomization of transition effects	X	X
Multilayer motion effects	X	X
One-click randomization of motion effects	X	X
Motion effects timing	X	X

Table i.1 *continued*

ProShow Version Differences

MOTION EFFECTS AND TRANSITIONS	GOLD	PRODUCER
Increased zooming range for motion effects	X	X
Motion smoothing (for creating smooth motion paths)		X
Motion keyframing (advanced motion timing)		X
Zoom X and Y coordinates individually		X
BUSINESS-ORIENTED FEATURES		
Copy-protect CDs		X
Watermark images and videos		X
Customizable branding features		X
End-of-slide actions		X
Color profile awareness		X
Custom templates		X
Capture frames		X
OUTPUT OPTIONS		
Burn slide show to Blu-ray Disc	X	X
Burn slide show to CD/VCD	X	X
Burn slide show to DVD	X	X
Output to streaming Web slide show	X	X
Free online sharing/slide show hosting at Photodex.com	X	X
Advanced playback controls for Web shows	X	X
YouTube uploading	X	X
Device output	X	X
Autorun CD and EXE output	X	X
Flash video output: FLV	X	X
Compressed AVI output		X
Uncompressed AVI output		X
MPEG-1 video	X	X
MPEG-2 video	X	X
Build screen savers	X	X
E-mail slide shows	X	X
QuickTime output	X	X
Windows Media Video (WMV) output	X	X
HD video file output for HDTV	X	X
Custom slide show menus	X	X
Save and load menus	X	X

Features list courtesy of Photodex.

THE PROSHOW
INTERFACE

1

At first glance, a full-featured program such as ProShow can seem a bit overwhelming, especially if you've never used an application like this. ProShow has hundreds of features to explore, but where do you start?

Thankfully, the designers of ProShow took this into consideration when developing the ProShow interface. Although ProShow has hundreds of features, they're well organized. The majority of the most commonly used functions are only one or two mouse clicks away at any time. The less frequently accessed commands are a couple of additional clicks from revealing themselves, but nothing is too far from the surface.

In this chapter, I'll explore the ProShow interface to help you get up to speed before diving into detailed examples of how to use those functions.

The Main Windows

The Gold and Professional versions of ProShow share a very similar interface. The main difference between ProShow Gold and ProShow Producer is the number of options you have when creating your shows. As an example, **Figure 1.1** shows the main window for ProShow Producer, while **Figure 1.2** shows the ProShow Gold main window. As you can see, other than an additional icon on the toolbar, they look identical.

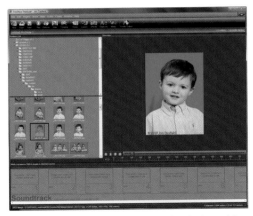

Figure 1.1 The ProShow Producer main window adds an Effects button to the toolbar but otherwise looks the same as the Gold version.

Figure 1.2 ProShow Gold looks nearly identical to the Producer version and works in the same way.

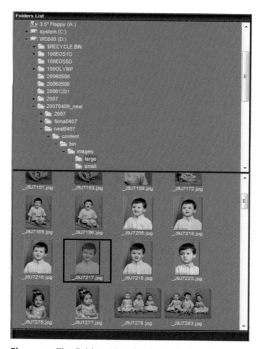

Figure 1.3 The Folders List should be familiar to anyone with Windows experience. You can navigate to any of your drives and folders to access content for your shows.

ProShow breaks this main window into segments. The first is the Folders List (**Figure 1.3**).

The Folders List is where you'll navigate to your content, whether it's an image, video, or an audio clip. The list is structured in the standard list view familiar to any Windows user. Click a folder to access the thumbnails in the lower portion of the panel, which allow you to see what that folder contains. For a closer look at any file, select it in the File List, and you'll see a larger version in the Preview panel to the right of the Folders List.

You can select files in the File List by clicking and dragging them to the Slide List below the Folders List and Preview panel (**Figure 1.4**). Alternatively, you can right-click a file and choose Add to Show. In Chapter 2, I'll cover how to organize content to make it easier to work with, as well as how to select the images, video, and audio that you'll be using in your shows.

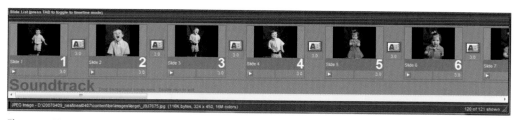

Figure 1.4 You can reorder images by dragging them into the Slide List, which shows all the content in your show. To add files to your show, drag and drop files from the File List into your show, or right-click a file or group of files and choose Add to Show.

The Preview panel (**Figure 1.5**) serves a dual purpose. First, it shows you a large version of an image or video that is selected in the File List. It also serves as a view of your slide show. Once you've started to add content to your Slide List, you'll see that the output type now shows an approximation of the size your show will be. Click the output type to cycle through the different options (**Figure 1.6**).

Selecting any slide in your Slide List will display it in the Preview panel; it will also show you how far into the show that slide is, along with the slide number. The standard VCR-type controls let you play your show without having to actually create the output, making it easy to experiment as you create your show.

If your slide has layers or other effects applied, you will see those shown in the Preview panel as shown in **Figure 1.7**.

Figure 1.5 The Preview panel shows the selected thumbnail or slide. It also serves as a preview for your show, letting you play with timing, transitions, and music prior to creating a show for output.

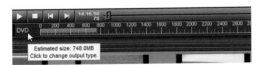

Figure 1.6 Clicking anywhere on the size bar below the playback controls will show you how large your show will be on the selected output type.

Figure 1.7 The Preview panel shows layers and other effects that you have applied to a slide so that you don't have to create the show to play it back.

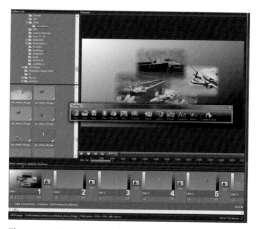

Figure 1.10 You can use the toolbar as a floating window, moving it around as needed. This is helpful when you're running your images at a lower screen resolution, because it allows you to keep your Preview panel as large as possible.

The Toolbar

The next main area of the ProShow window that you'll be spending quite a bit of time with is the toolbar (**Figure 1.8**).

The toolbar gives you quick access to many of the most commonly used features of ProShow so that you don't have to remember where they are in the menu system. If screen space is tight on your monitor, you can change the way the toolbar is displayed; for example, you can reduce the size of the icons by choosing Window > Toolbar and deselecting Large Toolbar buttons, as shown in **Figure 1.9**.

You can also "tear" the toolbar off to convert it to a floating window (**Figure 1.10**). To do this, click the black border at the left edge of the toolbar, and drag the window. You can now place this anywhere on your screen and move it as needed.

The toolbar is grouped into four sections. The first section contains the file options—New, Open, and Save. The second section holds the global adjustment buttons. These buttons operate on the entire show. The toolbar buttons in the third section open dialogs so you can control the slide options. Adjustments made in these dialogs affect only the selected slides, not the whole show. The final section of the toolbar is a single button that accesses the output options when you're ready to finish your show.

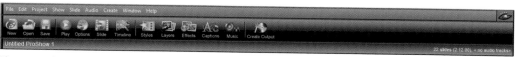

Figure 1.8 The ProShow Producer toolbar looks nearly identical to the toolbar in ProShow Gold. However, you can access the more powerful features in ProShow Producer by selecting options from the ProShow Producer toolbar.

Figure 1.9 Using the small icons toolbar will give you some extra space for your Preview panel and other windows. Choose Window > Toolbar, and deselect Large Toolbar buttons.

THE TOOLBAR

Workspace Organization

You can resize most panels in ProShow to work best with your particular needs. Just drag the border area to change the size. **Figure 1.11** shows my resized File List that lets me see more content at the expense of folders. Since I've already navigated to the folder I want, this is fine, and I can always restore the Folders List to the size I want later.

Also, you can convert some windows, such as the Slide List/Timeline, to floating windows (**Figure 1.12**); this allows you to keep them open, but they don't take up valuable space when you are viewing your show.

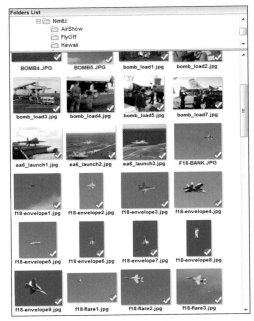

Figure 1.11 You can resize most of the panels in ProShow to suit your work needs. Compare this Folders List panel with the one shown in Figure 1.2, and you'll see that I have much more space for viewing files now.

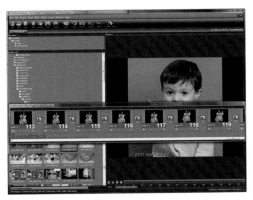

Figure 1.12 As with the toolbar, you can convert the Timeline/Slide List panel to a floating window to gain more space for your Preview panel while still having full access to all the needed features.

Figure 1.13 You can create and save window layouts to optimize the ProShow interface based on your work style.

If you come up with a layout that works well for you, you can save the workspace by choosing Window > Save Window Layout. You can then load the layouts by choosing Window > Load Window Layout and applying the saved layout in the Apply Custom Layout dialog (**Figure 1.13**).

If you start to experiment and get lost or you want to undo your edits, you can easily restore everything to its original layout by choosing Window > Default Window Layout.

WORKSPACE ORGANIZATION

Dialogs

Many of the dialogs in ProShow serve multiple purposes, grouping similar tasks into a single tabbed dialog (**Figure 1.14** and **Figure 1.15**).

In the Show Options dialog, you have access to all the Show, Caption, and Music commands. Some controls open additional specialized dialogs, such as the Edit Fades and Timing dialog (**Figure 1.16**).

Figure 1.14 The Show Options dialog in ProShow Gold has a tabbed interface that groups similar types of controls into one common area.

Figure 1.15 The Show Options dialog in ProShow Producer is similar to the one found in ProShow Gold but has more features, including the ability to add watermarks—which will help protect and promote your professional show.

Figure 1.16 From the main dialogs like Show Options, you can access feature-specific dialogs such as the Edit Fades and Timing dialog for editing music.

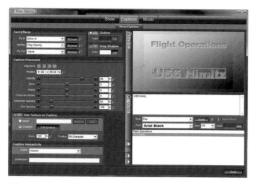

Figure 1.17 You can access the Show Captions settings in the Show Options dialog by clicking the Captions tab.

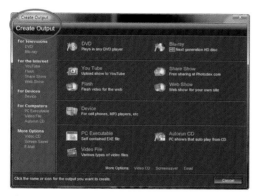

Figure 1.18 Some dialogs in ProShow are specific to a particular task, like the Create Output dialog. This dialog groups different types of output together so that all your output options are available in one place.

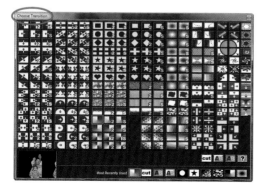

Figure 1.19 Another example of a single-purpose dialog is the Choose Transition dialog. Along with a number of transitions to choose from, you can preview the effect within the dialog.

Click the Captions tab in the Show Options dialog to display all the options available for working with text in your show (**Figure 1.17**).

Other dialogs are single purpose, like the Create Output dialog (**Figure 1.18**). This dialog houses all the output options offered by ProShow, from CD to Blu-ray and from e-mail to YouTube.

Another example of a single-use dialog is the Choose Transition dialog (**Figure 1.19**), which you can access by clicking the transition button between each slide. This dialog gives you immediate access to the more than 280 transitions in ProShow.

Many items in the ProShow interface also have context menus that you can use to access features that are specific to the selected item. Right-clicking a slide in the timeline, for example, will show you all the commands that are available for that slide (**Figure 1.20**).

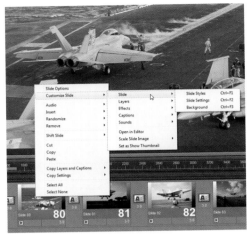

Figure 1.20 You can also right-click most items in the ProShow interface to access context-sensitive options for that item, a handy shortcut to help speed your workflow.

CREATING
YOUR FIRST SHOW

2

Now that you have the ProShow UI basics down, it's time to dig in and start creating your first show. In this chapter, you'll start by looking at ways to optimize your workspace for content. Then you'll learn how to set the timing for slides, add titles and other text, and use transitions to make your show more visually interesting.

Preparing Your Images

ProShow can work with most image types, including TIFF, BMP, JPEG, GIF, and, in the case of ProShow Producer, some RAW files. But these files are often not in the right size for your show. Although you can let ProShow resize images to fit the selected output options, you can control how those images are resized by doing it yourself in advance.

If you know that your show will be shown only at a certain resolution—for example, on the Web—you can size the images appropriately to about 800 x 600, which will work fine on most monitors and keep the show playing smoothly over an Internet connection.

For general use, however, I suggest setting the resolution to 1920 x 1200. This will be large enough to create a high-definition (HD) show on a Blu-ray disc.

If you use Adobe Photoshop, you can easily resize images to fit within specific dimensions.

To resize images for specific dimensions:

1. Open your image in Photoshop.

2. Choose File > Automate > Fit Image. You'll see the Fit Image dialog (**Figure 2.1**).

3. Enter the dimensions you want to use. In the example shown here, I've used 1920 for Width and 1200 for Height.

4. Click OK. Your image will now be sized to fit within these dimensions, with no side being longer than 1920 pixels or higher than 1200 pixels.

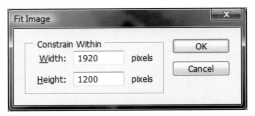

Figure 2.1 You can use Photoshop to resize your images to fit within specific dimensions. The Fit Image dialog lets you set the size of the image regardless of the image orientation.

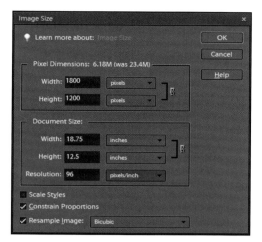

Figure 2.2 In Photoshop Elements you use the Image Size dialog to set the dimensions of your images. You'll need to input either the width or the height, depending on the orientation of your image. Photoshop Elements will enter the other number automatically when Constrain Proportions is selected.

If you're using Adobe Photoshop Elements, you'll need to use the Image Size command (this also works in Photoshop).

To resize using the Image Size command:

1. Open your image in Photoshop Elements.

2. Choose Image > Image Size to open the Image Size dialog (**Figure 2.2**).

3. Be sure the Resample Image check box is selected, and then enter either the width for landscape orientation or the height for portrait orientation. As long as Constrain Proportions is selected, Photoshop Elements automatically enters the correct number in the other dimension box to maintain the proportions of your image.

Setting the Resolution

For screen display, a lower resolution is appropriate. Although you might print with 300 pixels per inch (ppi), a computer display or TV doesn't need this much resolution. In fact, high resolution will provide no additional benefit and will increase the file size of your images. A good choice for image resolution is 96 dots per inch (dpi).

To set resolution in the Image Size dialog:

1. With your image open, choose Image > Image Size.

2. Enter **96** for the resolution, with pixels/inch as the scale. Click OK to set the resolution of the image.

Working with Groups of Images

The examples discussed so far have dealt with individual images. Often you'll want to perform the same tasks on large numbers of photos, and for this process you can use the automation features in both Photoshop and Photoshop Elements.

If you use Photoshop, you have a bit more control over the process with the Image Processor dialog that is included with Photoshop.

To use the Image Processor in Photoshop:

1. Choose File > Scripts > Image Processor to display the Image Processor dialog (**Figure 2.3**).

2. You have the option of working with files that are already open in Photoshop or processing entire folders of images. To work with folders, select the Select Folder radio button, and click the Select Folder button to open the Choose Folder dialog and navigate to the folder that contains your images. If you have multiple folders within that main folder, you can select the "Include All sub-folders" check box.

3. Choose the location where you want to save your processed files. Although you can save the images in the original folder, I suggest creating a new folder to avoid confusion when you're adding content to your show. To create a new folder at this point, click the Make New Folder button in the Choose Folder dialog.

4. Under File Type, select the Save as JPEG check box and the Resize to Fit check box.

5. I set Quality to 10 to retain the most image detail possible. For the resize options, enter the dimensions you've decided on for your show—in this example, 1920 x 1200.

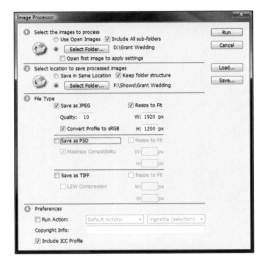

Figure 2.3 The Image Processor command in Photoshop can perform a number of operations for you in a single dialog. You can resize, convert, and save copies of your images using this dialog.

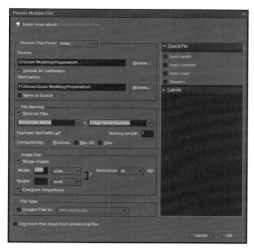

Figure 2.4 You can process large numbers of files in one operation by choosing the Process Multiple Files command in Photoshop Elements.

6. Select the Convert Profile to sRGB check box. This gives you the best color possible on a computer screen or TV.

7. Finally, under Preferences, select the Include ICC Profile option to make sure the sRGB profile is used with your images.

In Photoshop Elements, you can work with files located in a single folder (and its sub-folders).

To use the Process Multiple Files command:

1. Choose File > Process Multiple Files to open the Process Multiple Files dialog (**Figure 2.4**).

2. In the Process Files From section, browse to locate the folder that contains your image files. If you have multiple folders within that folder, you can select the Include All Subfolders check box.

3. Select the destination for your resized images. You can either use the same folder by selecting Same as Source or define a new folder. I suggest using a new folder to avoid confusion later when you're adding files to your show.

4. Under File Naming, you can rename the files if you want, or if they already have the names you want to use, deselect the Rename Files check box.

5. Under Image Size, select Resize Images. Set either the width or the height that you've chosen for your files.

6. Select 96 dpi as the resolution.

7. If your files are not saved as JPEGs already, you can convert them in the File Type section by selecting the "Convert Files to" check box and choosing either JPEG High Quality or JPEG Max Quality.

Managing Color

Images viewed on different devices almost always have a different look to them. Colors that are accurate on one computer may appear oversaturated on another or have a color cast to them that you know shouldn't be there.

Although you'll never be able to correct for this completely since you cannot control which device someone uses to view your show, you can at least ensure that your images will look their best on the widest range of displays possible. To do this, use the correct color settings for your images.

Computer displays, projectors, and many newer TVs are optimized for a color space or profile known as sRGB IEC1966-2.1 (often called simply sRGB). If you use this color space, most monitors and TVs will display pretty accurate representations of your images.

In the previous section, I showed you how to use the Image Processor command to convert your images using the color profile. You can also do this by choosing the Edit > Convert to Profile command in Photoshop and selecting sRGB IEC61966-2.1 from the Profile drop-down menu under Destination Space (**Figure 2.5**).

You have fewer choices in Photoshop Elements, but the ones you do have are the primary ones. In Photoshop Elements, choose Edit > Color Settings. If it isn't already selected, select Always Optimize Colors for Computer Screens (**Figure 2.6**). This wordy option will convert your images to sRGB when you save them.

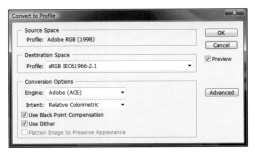

Figure 2.5 Be sure that your images use the sRGB color space, or *profile*, to ensure the best possible color on all displays.

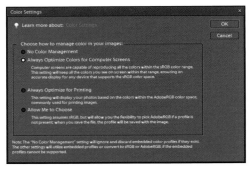

Figure 2.6 In Photoshop Elements, you can optimize your images for screen or print. Be sure to select the Always Optimize Colors for Computer Screens option when working with images for your slide shows.

Figure 2.7 Using a simple folder structure can keep your files organized and help simplify the process of adding content to your shows.

Figure 2.8 This is a typical setup for a wedding show. I have image folders for each part of the event to help organize them (Ceremony, Formal, and so on), as well as separate folders for video and music.

Adding Content

Although you can add content, such as images, video, and music, from anywhere on your computer, I find that it's much easier to work with copies of my files in a folder structure that is set up specifically for the show. This method offers several advantages: You'll be working on copies, not the original files, and everything will be in a central location—no jumping around your computer hunting for files in different folders or on different drives. In addition, you'll have a self-contained backup for your show.

To create a show folder:

1. Create a new top-level folder for your show. I typically use the name of the event or subject of the show to name the folder.

2. Create folders inside this top-level folder, one for each type of media that you will use in the show. In **Figure 2.7**, I use Images, Music, and Video, for example.

3. Copy the prepared images into the correct folders (**Figure 2.8**).

✔ Tip

■ If you plan to make several shows, I recommend creating a folder called Template that has the empty folders ready to go. Then you just duplicate the top-level folder and rename it, and you're ready to add content to a given show.

ADDING CONTENT

To bring your images into ProShow:

1. Using the Folders List, navigate to the folder containing your image files (**Figure 2.9**).

 Using any of the following methods, select the images you want to use:

 - ▲ Click a single file.
 - ▲ Click and drag to select multiple files.
 - ▲ Click the first image; then hold down the Shift key and click the last image to select a range of files.
 - ▲ Control-click individual files to select noncontiguous files.

2. With your files selected, drag them to the Slide List, or right-click and choose Add to Show (**Figure 2.10**).

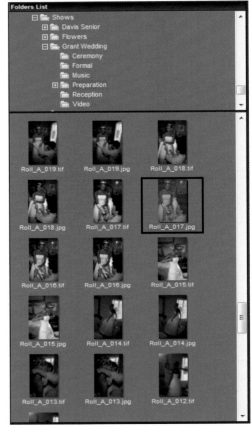

Figure 2.9 Using the Folders List, locate the folder that contains the images you copied and prepared for your show.

Figure 2.10 With the files selected, drag them onto the Slide List to add them to your show.

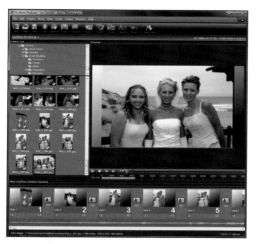

Figure 2.11 The images that have been placed in a show will be tagged with a check mark in the Folders List to help you identify what is already in use.

Figure 2.12 Drag a slide to change the order in which it appears in your show.

Figure 2.13 Select a slide to change the length of time it is displayed in your show. Typing a different number will change the duration to that value.

Once you've placed an image in the show, you'll see a check mark on the thumbnail in the Folders List (**Figure 2.11**). If you added a file you don't want, simply select it in the Slide List and press Delete. This removes the slide from the show without deleting the image from your disk.

Changing the Order of Slides

After placing images in your Slide List, you might find that you want them to appear in a different order. To change the order of a slide, just drag the slide you want to move to the new position. You'll see a highlight on the left edge of the slide to indicate where the slide will be placed if you release the mouse button (**Figure 2.12**).

Changing the Duration of Slides

By default, slides are displayed for three seconds. The amount of time is shown below the slide number, and you can change it to any value you want. For the typical show, three seconds is a good choice. It gives your viewer enough time to see what's on the slide without getting bored waiting for the next image to appear.

There are exceptions to this, however. If your slide contains text, you'll want to leave it onscreen longer. How long depends on the amount of text. I suggest reading your text at a normal pace to see how long it takes you and then adding one or two seconds to that time as a starting point.

To change the length of time a single slide is displayed, click that slide, and then click the small 3.0 below the slide number. This selects the text, allowing you to enter a new time (**Figure 2.13**).

ADDING CONTENT

To change the viewing time of multiple slides to the same length, select them by Shift-clicking or Control-clicking, and then enter the new number (**Figure 2.14**).

You can also set the timing in the Slide Options dialog. First click the Slide button in the toolbar to access most of the options for making adjustments to a slide. You'll see three tabs, each with different groups of functions. You can find the timing adjustment on the Slide > Slide Settings tab (**Figure 2.15**). On the left side of the dialog in the Slide Timing section, select the Slide Time field and enter a new value.

Adjustments made in the Slide Options dialog affect only the current slide.

To make changes to multiple slides:

1. Select all the slides you want to modify in the Slide List by Shift-clicking to select a range of slides or Control-clicking to select slides that are not together.

2. Click the Slide button in the toolbar, or choose Slide > Slide Options to open the Slide Options dialog.

3. At the lower left of the Slide Options dialog you'll see a set of arrows and a slide counter (**Figure 2.16**). Clicking the arrows will move back or forward one slide. Edits to each slide will be saved when you click the OK button.

Figure 2.14 You can change the display time of multiple slides all at once by selecting them and entering a new value into any of the selected slides.

Figure 2.15 You can also set the timing for slides in the Slide Options dialog. This method works on individual slides only.

Figure 2.16 You can move to other slides within the Slide Options dialog by clicking the forward and back buttons in the lower-left corner.

Figure 2.17a The Captions options are located in the Slide Options dialog. The Caption Settings panel in ProShow Producer offers more options than the Caption Settings panel in ProShow Gold.

Figure 2.17b The Caption Settings panel in ProShow Gold offers fewer options, but the basics of creating a title are the same in both the ProShow Gold and ProShow Producer editions.

Adding Titles and Text

At a minimum, you'll want to have a title slide for your show to let your viewers know what they'll be seeing. Even if it's a family vacation, years down the road it will be nice to know when and where the photos were taken.

The simplest title slides consist of just text with no images or effects.

To create a new title slide:

1. Select the first slide in the Slide List.

2. Choose Slide > Insert > Title Slide (or right-click the first slide and choose Insert > Title Slide).

3. ProShow creates a new blank slide for you, and the Slide Options dialog appears with the Captions category and Caption Settings tab selected (**Figures 2.17a** and **2.17b**).

continues on next page

4. Click the Captions field to select it, and then enter your title (**Figure 2.18**). As you type, the Preview panel will display your text.

5. To change the font, choose one from the Font list. You can also change the color of the text and choose bold or italics.

6. To resize the text, you can enter a specific size in the Size drop-down menu or simply drag the selection handles around your text until you arrive at the size you want (**Figure 2.19**).

7. Position the caption on the slide by clicking within the selection handles and dragging to the new location.

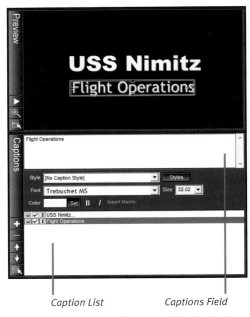

Caption List *Captions Field*

Figure 2.18 Enter the text for your title in the Captions field. You can include multiple captions, each with its own properties.

Selection Handles

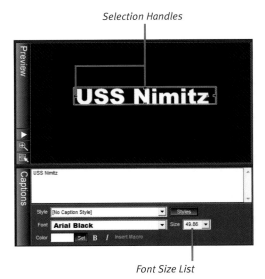

Font Size List

Figure 2.19 The easiest way to resize text for your captions is to drag the selection handles until your text is the size you want. As an alternative, you can enter a specific size in the Size drop-down menu.

Figure 2.20 To align the text in multiline captions, use the Alignment choices in the Caption Placement options.

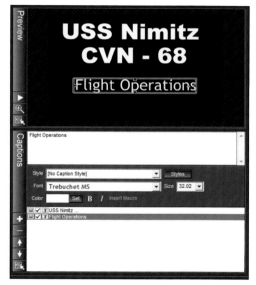

Figure 2.21 Adding a second caption lets you change the font and styling.

Figure 2.22 The Position fields control the horizontal and vertical placement of the text on your slide.

To create multiple-line captions with the same style, press Enter, and align the text using the Caption Placement options (**Figure 2.20**). Centered is a good choice for multiline captions.

If you want to apply different formatting to your caption text on the same slide, you'll need to add multiple captions. This enables you to choose different fonts, colors, sizes, and, as you'll see in Chapter 3, different transition and motion effects.

To add a second caption, click the plus (+) button in the Captions panel (**Figure 2.21**). Enter the text of the caption in the Captions field, and it will appear in the Preview panel.

To position the caption on your slide, use the Caption Placement settings (**Figure 2.22**). The Position fields use percentages for horizontal and vertical placement. The first number is the horizontal position. If you have set the alignment to centered, entering **50** here will center the text exactly on the slide. If you choose left or right alignment, the text will begin or end at the center of the slide.

Adding Text to Slides

The same captioning features also apply to slides that aren't title slides. You can add text to an individual slide or to multiple slides at one time. To add text to a regular slide, select it in the Slide List and click the Captions button in the toolbar. **Figure 2.23** shows a caption applied to a regular slide, and as you can see, it's the same dialog with the same options as when you create a blank title slide.

You can also apply the same caption to every slide in your show. This is useful when you want to have a consistent look from one image to the next—for example, when using a copyright label on each image. To apply this type of caption, click the Options button (), or choose Show > Show Settings.

Click the Captions tab. You'll note that in this dialog (**Figure 2.24**), while the controls are the same as in the other Captions dialog, you now see that the tab is listed as Show Captions, and regardless of what slide is selected, only the background appears in the Preview panel. This indicates that any captions added here will be applied to every slide in your show.

✔ Tip

- To add the copyright symbol (©), press and hold the Alt key while typing **0169** on the numeric keypad (this will not work with the number keys above the alphabet keys).

 I frequently use this method to apply a quick copyright statement to each slide in a show, as you can see in **Figure 2.25**.

Figure 2.23 The process for applying captions to slides with images is identical to creating a title slide. Rather than creating a new blank slide for your text, you apply the text to an existing slide.

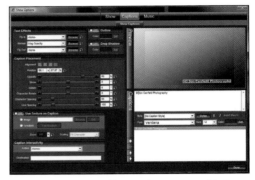

Figure 2.24 You can add a caption to every slide in your show using the Show Options dialog. This is useful for adding a copyright or other information to all the slides.

Figure 2.25 Adding a caption to each slide in your show is an effective way of adding your name and copyright.

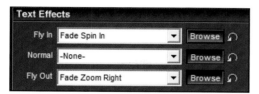

Figure 2.26 You can control how captions are displayed with the Text Effects settings. Set different options for caption start (Fly In), display (Normal), and caption exit (Fly Out).

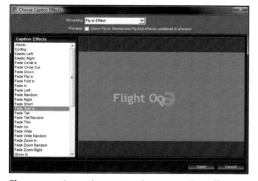

Figure 2.27 An easier way to choose caption effects is to click the Browse button. This lets you preview all the effects before applying them.

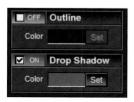

Figure 2.28 You can also add outlines and drop shadows to your captions to set them off from the background.

Applying Basic Text Effects

Plain captions might seem a little boring, but they're often the most effective, helping your viewers concentrate on the message rather than the special effects. Having said that, you'll most likely want to experiment with text effects for your captions. ProShow lets you control how the caption is initially displayed, what effects are applied, and whether any effects are displayed when the text leaves the screen. The Text Effects panel includes the Fly In, Normal, and Fly Out options (**Figure 2.26**).

You can select from one of these drop-down menus, but an easier method, until you get familiar with the effects, is to click the Browse button. This opens a new window listing all the effects and providing a large Preview panel so that you can see the function of each effect (**Figure 2.27**).

The final options I'll cover are the Outline and Drop Shadow settings (**Figure 2.28**).

continues on next page

ADDING TITLES AND TEXT

To add either of these embellishments to your caption, select the On check box. This activates the color picker. Click Set to open the color picker, and choose a color by selecting the hue from the outer ring and the saturation from the inner triangle (**Figure 2.29**).

If you want to use a color that matches something in one of your slides, you can use the eyedropper in the color picker.

To select a color to match your slides:

1. With the Slide Options dialog open, choose the slide with the color you want to use from the Slide List.

2. If it isn't already activated, select the Outline or Drop Shadow check box in the Caption Settings panel of the Slide Options dialog.

3. Click the Set button to open the color picker.

4. Click the eyedropper to select it, and then click the color in your slide that you want to use (**Figure 2.30**).

When you've made all your adjustments to the slide, click OK to apply them and return to the main ProShow window. You can preview your slide by clicking the Play button ▶ (**Figure 2.31**).

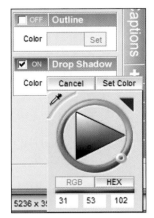

Figure 2.29 Use the color picker to set a color for your outline or drop shadow.

Figure 2.30 You can use the color picker to select a specific color from one of your images to be used as the outline or drop shadow color.

Figure 2.31 To see how your captions look, click the Play button below the Preview panel.

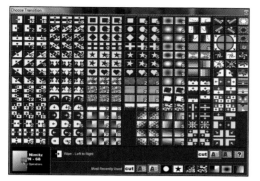

Figure 2.32 The Choose Transition dialog includes more than 280 options.

Applying Transitions

A good slide show uses transitions to move from one image to another. ProShow has more than 280 transitions to select from, so odds are you won't have any problems finding just the right one for your show.

Exploring Transition Basics

By default, ProShow uses a simple cross-fade blend with a *linear*, or constant, rate of change. You can see which transition is in use by looking at the small button between each slide (![button]). This button shows the current transition as well as the duration of the transition. As with slides, the default duration is three seconds. Transition timing is distinct from slide timing, so if your slide is set to display for three seconds, you'll see it for the full three seconds before the transition begins.

To change a transition, click the transition button between the slides you want to change.

In the Choose Transition dialog that appears, select the transition you want to use (**Figure 2.32**). As you move your pointer over each transition, you'll see a preview of that effect in the lower-left corner of the dialog.

Once you select a transition, the dialog closes. Your most recently used transitions are listed at the lower right of the dialog, enabling you to easily select them again.

The transitions are grouped into similar variations, such as wipes, fades, and patterns. Icons that display a *2* in them (like this: ![icon]) use two passes to complete the effect. Icons displaying an *S* (like this one: ![icon]) have a soft-edge effect.

To set the transition for multiple slides, select the slides by holding down the Control key while clicking them. If you want to set the transition for the entire show, select all the

continues on next page

slides by clicking any slide in the Slide List and choosing Edit > Select All (or pressing Control-A), and then click the transition button. This applies the selected transition to all selected slides.

Choosing Transitions

Often, the simplest techniques work best. A well-designed show will use only a few different transitions throughout to keep the focus on the content of the show rather than the glitz of special effects. If you want to vary the transitions in your show, you can select a random transition. ProShow offers two commands for random transitions. The first, Randomize Transitions, selects a random transition for each slide in the show. You can change the selected transition for any slide if you want. The second is Random Transition. This option selects at random a single transition to be used throughout the show each time it's played.

To use Randomize Transitions, select the slide or slides you want to apply the effect to in the Slide List. Then choose Slide > Randomize > Randomize Transitions. This applies a random transition effect to each selected slide (**Figure 2.33**). As you can see

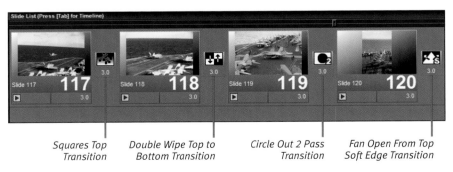

Squares Top Transition Double Wipe Top to Bottom Transition Circle Out 2 Pass Transition Fan Open From Top Soft Edge Transition

Figure 2.33 Using the Randomize Transitions command sets a different transition for each of the selected slides. You can modify these by changing the selection in the Choose Transitions dialog.

Figure 2.34 The Random Transition command will use a different transition throughout a show each time the show is played.

Random Transition

in the example, each slide is using a different transition (Squares Top between slides 117 and 118, Double Wipe Top to Bottom between 118 and 119, Circle Out 2 Pass between 119 and 120, and Fan Open From Top Soft Edge between slides 120 and 121).

To use the Random Transition command, select the slide or slides you want to apply the effect to and then click the transition button.

Click the question mark button (**?**) to set the effect for the selected slides. This transition is located in the lower right of the Choose Transitions dialog (**Figure 2.34**). With this selection, a different transition will be used throughout a show each time it is played.

Supplemental Materials

You can find sample shows that demonstrate each of the caption and transition effects online at the companion Web site (www. proshowbook.com/chapter2).

Another great source of information is the ProShow Enthusiasts group, which has a very active forum. You can find this group at www.proshowenthusiasts.com.

3

BEYOND THE BASICS

In Chapter 2, you learned how to create simple slides, adjust timing and transitions, and create captions. In this chapter, you'll build on the skills you have picked up with the addition of layers, motion effects, music, and caption effects. You'll start with the addition of multiple layers to a slide and learn how to move them around. From there, you'll add some music and learn how to adjust timing to the show. Finally, you'll add some captions and add some effects to liven them up a bit.

These effects will really begin to distinguish your show visually and help you produce a complete piece.

Working with Layers

One great benefit of using layers in ProShow is that you don't have to learn a new skill. If you have ever used Adobe Photoshop or another image-editing program, you've probably worked with layers before. Basically, a layer is any image that appears on your slide—and you can create as many as you want.

You control each layer in ProShow independently, which means that you can tell every layer to do what you want it to do, just as you did in Chapter 2.

Adding New Layers

Adding new layers to a slide just builds on what you have already done. You can add layers to a slide in a few different ways, and the method you choose depends entirely on what you are most comfortable with.

To add new layers to a slide:

1. Use the Folders List to navigate to your image files. Once you find them, they appear in the File List as thumbnails (**Figure 3.1**).

2. Create a new slide by dragging an image to the Slide List. From here, you have two options for how to add layers:

 ▲ Select another image in the File List, hold down Control, and drag the image over the slide you just created (**Figure 3.2**).

 ▲ Double-click the slide to open the Slide Options dialog. Select the Layers tab and then Layer Settings, and click the Add Layer button (**Figure 3.3**) ![+] in the Layers list. We'll go over this in more detail in a moment.

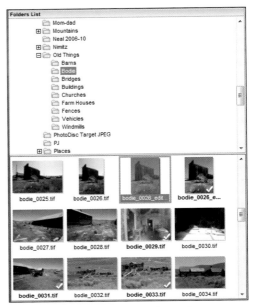

Figure 3.1 The Folders List is used to navigate to your image files, which will appear in the File List as thumbnails for selection.

Figure 3.2 Click a thumbnail in the File List, hold down Control, and drag the image onto the slide you created.

Figure 3.3 Click the Add New Layer button to create another layer on your slide.

Figure 3.4 After you drag the second image onto the slide, the Slide List is updated to show the new top layer of the slide.

Figure 3.5 Choose Add Image or Video after clicking the Add Layer button to add a new layer of your choice to the slide.

Figure 3.6 Select the image you want to add to the layer.

Figure 3.7 Each layer has a number, and layers are stacked in order on top of one another like layers in a cake.

After you drag the new image to the slide, the Slide List will update to show the top layer (**Figure 3.4**).

You can also add a layer using the Slide Options dialog.

To add a layer using the Slide Options dialog:

1. Double-click the slide to open the Slide Options dialog.

2. Select the Layers tab and then Layer Settings. Click the Add Layer button in the Layers list.

3. Choose Add Image or Video (**Figure 3.5**) and use the File Open dialog to select the image you want to add. Click Open (**Figure 3.6**).

Now that you have added a new layer, look at your Layers list. You will see two layers there, each with a number. Number 1 is at the top of the list and is the top layer. Number 2 is just beneath it (**Figure 3.7**).

These layers stack on top of one another like layers in a cake or cards in a deck. When one layer has been placed directly on top of another, you can see only the top layer. Changing the zoom, position, and rotation of each layer will allow you to see multiple layers stacked on each slide. You'll learn how to do that now.

✔ Tip

■ Keyboard shortcuts can save lots of time during show creation. Get comfortable with them, and use them often.

WORKING WITH LAYERS

Preparing Layers

You will be adjusting and manipulating layers for almost all the effects you create on a slide beyond just showing a single image.

Thankfully, you can quickly change layers to suit whatever effect you may have in mind, either with your mouse or, for more precision, with slider bars and values. Use whichever method works best for you.

Before you start on layer adjustments, be sure to name your layers. You can enter a name for your layer in the Layer Name field (**Figure 3.8**).

This field, combined with the Layer Notes field, will help you remember the contents of each layer. The name appears in the Layers list once changed, so it's easier to keep track of what each layer in your slide does.

Changing Scaling

The Scaling value determines how a layer will appear on the slide frame, and you have quite a few options from which to choose. Each will slightly change the way the layer is displayed:

◆ "Fit to frame" ensures that the layer fits within all four edges of the slide, or the *frame* of the slide (**Figure 3.9**). If you have a layer that doesn't perfectly match the size of the frame, some of the slide background will be visible.

◆ "Fill frame" ensures that the image layer fills the entire slide frame so that no background can be seen (**Figure 3.10**). If the layer doesn't perfectly match the size of the slide frame, some edges may be cut off.

◆ "Stretch to frame" ensures that the layer fills the entire frame but will change the proportions and size of the image to do

Figure 3.8 Once you enter a name in the Layer Name field, it appears in the Layers list.

Figure 3.9 A layer that fits within the four edges of the slide, or the *frame*.

Figure 3.10 A layer that has been set to "Fill frame." This setting may cut off some edges if the image area doesn't exactly match the slide frame.

Figure 3.11 A layer that has been set to "Stretch to frame." Be careful with this option, because it can cause distortion in images that have different orientations.

Figure 3.12 The safe zone is identified by the diagonal lines around the border of the layer. Keeping your layer inside of these areas will prevent any unwanted cropping of the image on playback.

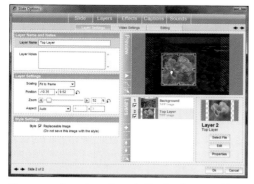

Figure 3.13 Dragging a layer in the Preview panel is the fastest and easiest way to set the position.

this (**Figure 3.11**). This can distort layers if they are in a different orientation. For example, a portrait layer stretched to fill a landscape frame will cause the image to appear very wide.

◆ "Fit to safe zone" and "Fill safe zone" work just like the "Fit to frame" and "Fill frame" options, except that they use the safe zone of your slide for the edges. This is how you can make sure your slides are using the safe zone, if needed. The safe zone is identified by the lined area around the border of the Preview panel (**Figure 3.12**). Keeping your layer within the boundaries of the safe zone will prevent any possible clipping, or unwanted cropping, of your layer on playback.

Changing Position

Changing a layer position is simple—just change where it rests on the slide. You can do this in two different ways: visually or numerically. Visually changing the position of a layer is far easier and more efficient.

To change the position of a layer, click it in the Preview panel, and drag it to the desired location (**Figure 3.13**). The position will be saved. Notice that while you do this, the position values update to show where the layer has been placed. This can help you learn the positioning values to place the layer more precisely, if needed.

✔ Tip

■ When you are ready to use precise values for the position of your layers, make sure you know the grid. The slide grid is just like any grid in geometry. It goes left to right on the x-axis, from -100 to 100. It goes up and down on the y-axis using the same values. The left position value is X, while the right is Y.

WORKING WITH LAYERS

Changing Zoom

The Zoom value of a layer can also be considered the size of a layer. Zooming in on a layer increases its visual size, or the size it appears onscreen, and zooming out decreases the size.

Combining zoom with position, you can place a layer exactly the way you want it and can more easily see other layers on a slide.

Changing the Zoom value is easy. Click the layer you want to adjust, and drag the Zoom slider left to decrease the zoom or drag it right to increase the zoom (**Figure 3.14**).

You can also type in the Zoom value manually if you know exactly what you want. The range for the Zoom control is 0 percent to 500 percent.

An even easier way to adjust zoom is to use your mouse wheel if you have one. Move your pointer over the Preview panel, and roll the mouse wheel forward to zoom in or backward to zoom out. This allows you to make quick visual changes to your layer zoom painlessly.

Changing the Aspect Ratio

Aspect ratio—or Aspect, as it appears in ProShow—controls the proportions of your image (**Figure 3.15**). Most images have their own defined proportions based on how the shot was taken, or created, such as 4:3 for a typical digital camera or 16:9 for an HD video.

Normally, ProShow uses the Auto value to let the image use its normal aspect ratio. The Aspect setting allows you to change the ratio on each layer if you want.

Figure 3.14 Dragging the Zoom slider to the left decreases the zoom, while dragging it to the right increases the zoom.

Figure 3.15 The Aspect control determines the proportions of your image.

Figure 3.16 The Preview panel is always available to help you visually inspect your slide and make sure your slide looks the way you want it to look.

Figure 3.17 The Preview dialog gives you a larger view of your slide while still providing access to adjustment controls.

You can choose from the normal settings for TV display, such as 4:3 for standard-definition screens or 16:9 for wide-screen. You can also create your own aspect using the Custom value. You may want to avoid this setting until you are more comfortable with the setting, because using the Custom setting, an advanced feature, may cause distortion in your images.

Working with the Preview Panel

The Preview panel is a powerful tool that appears in every options dialog you see. You can always use it to make quick adjustments to layers or to see what your slide looks like.

The Preview panel has tools built into it that can help you work quickly and control exactly what you see (**Figure 3.16**).

The button you are likely to use the most is the Play button ▶. When you click the Play button, the slide plays back in the Preview panel so you can see whether you like what you have done. This is much faster than playing the regular preview in the main workspace, and it can help you double-check your slide to make sure you haven't made any mistakes.

The Precision Preview button 🔍 opens the Preview dialog (**Figure 3.17**). Here you'll see a larger panel for looking at your slide contents and all the same controls in a different layout optimized to give you a closer look at your layers.

Controlling the Layers List

The Layers list is another useful panel that shows up in every options dialog and allows you to work with layers (**Figure 3.18**).

Using this list, you can select any of the layers on your slide, add new layers, delete layers, and change the order of the layers you have.

We've already covered the Add Layer button at the beginning of the chapter. If you have a layer that you want to remove, however, you can click the layer that needs to go and then click the Delete Layer icon []. This will immediately remove the layer from the slide.

Beneath the Delete Layer icon are the Move Up [] and Move Down [] icons. If you want to move a layer up in your list, click the layer you want to move, and click the Move Up icon.

If you have a layer you want to move down, just click the layer, and click the Move Down icon.

This will change the way layers are stacked and how they overlap with one another (**Figure 3.19**).

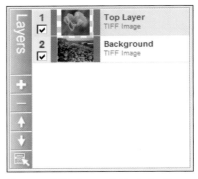

Figure 3.18 The Layers list includes the controls you need to add, remove, and reorder layers on your slides.

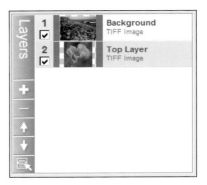

Figure 3.19 Moving a layer up or down changes the layer order, as well as the way the layers stack on the slide.

WORKING WITH LAYERS

Figure 3.20 The Soundtrack bar is where your music tracks are added to the show.

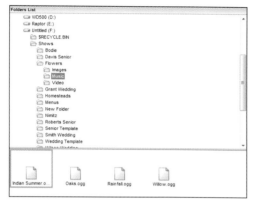

Figure 3.21 Use the Folders List to select the music you want to add to your show.

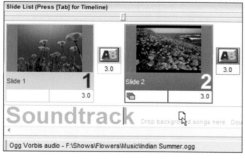

Figure 3.22 Drag any music you want to add to the show, and drop it on the Soundtrack bar.

Working with Music

ProShow is designed to make true multimedia slide shows, and music is a natural part of that process. You have an entire suite of tools available to add, customize, and time music to set your show apart and capture the emotion you want to convey.

Adding and configuring music in ProShow is just as simple as working with images—and in many cases you use the same process. Let's start by looking at how you can add music and quickly configure it to match the show you have created.

Adding Music

You can add music into your show using the same drag-and-drop method that you use to add images. Just below the image thumbnails for your slides is the Soundtrack bar (**Figure 3.20**).

To add music to your show using the drag-and-drop method:

1. Use the Folders List to open a folder that contains your music (**Figure 3.21**).

2. Select the track you want to include in your show from the File List, and drag it to the Soundtrack bar, just beneath the Slide List (**Figure 3.22**).

continues on next page

Notice that when you add audio to the show, it appears as a waveform beneath the slides, showing that music will be playing during that part of the show (**Figure 3.23**).

Dragging and dropping your music is the easiest way to add it to your show. If you prefer to find the music using the Show Soundtrack tab, you can use this approach as well.

To add music using the Show Soundtrack tab:

1. Click the Music icon in the toolbar to open the Show Soundtrack options. Once this is open, you will see the Soundtrack list on the right side of the tab (**Figure 3.24**).

2. When you want to add a new piece of music to your show, click the Add icon to open a file browser.

3. Locate the music on your hard drive, select it, and click Open.

The new music track will appear in your Soundtrack list and will be added to the show (**Figure 3.25**).

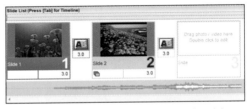

Figure 3.23 Audio files added to the Soundtrack bar display a waveform that shows where in your show the music will play.

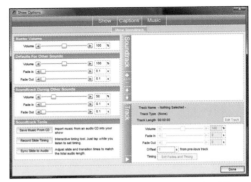

Figure 3.24 The Soundtrack list is on the right side of the Show Soundtrack tab. Here you can see all the music files you've added to your show.

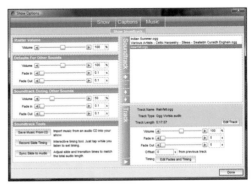

Figure 3.25 After you add the soundtrack to your show, it will be listed in the Soundtrack list.

Figure 3.26 The Master Volume slider controls the volume of your entire show. Moving it to the left decreases the volume, and moving it to the right increases it.

Figure 3.27 The Defaults For Other Sounds options control all audio in your show other than your music—that is, slide sounds.

Figure 3.28 The settings in the Soundtrack During Other Sounds section control what your music does when a slide sound is playing.

Configuring Music

You can fully customize and configure any music you want to use in your show according to your preference. While you have the Show Soundtrack tab selected, let's take a look at the options you can adjust and how these affect your music.

The Master Volume slider sets exactly how loud the music in your show will be. The slider changes all your music tracks at once, no matter how many you have. Move the slider to the left to decrease the volume, and move it to the right to increase the volume (**Figure 3.26**).

The Defaults For Other Sounds options control every sound in your show other than your music files (**Figure 3.27**). This means you can change the default values for sound effects that are attached to slides. Slide sounds, which are specific sounds played when a slide is onscreen, will be covered in more detail in Chapter 7.

Sliding the Volume slider to the right increases the volume, while sliding it to the left decreases it.

The Fade In and Fade Out sliders control how long other sounds will take to fade in to full volume at the beginning of the track or fade out to nothing at the end of the track. It's best to leave these at their default values of 0.1 seconds unless you need something longer.

In the next section, Soundtrack During Other Sounds, you can configure what your music does when a slide sound is playing (**Figure 3.28**).

You may notice in some films, and most often in documentaries, that when narration or sounds play, any music in the background decreases in volume. That's exactly what this feature does for you.

continues on next page

The Volume slider here controls the volume of your music when a slide sound is playing—for example, some voice narration that you make. By default, this value is 50 percent. That means that the music will drop to half volume when another sound effect is playing. This can be very handy when you are mixing music, sound effects, and narration together.

If you want to increase the volume, move the slider to the right. To decrease it, adjust the slider to the left.

You can also control the Fade In and Fade Out times here as well, again by moving the slider back and forth.

Now take another look at the Soundtrack list on the right (**Figure 3.29**). Notice that there are a few additional icons besides Add. You can also delete music or move it up and down in the list.

The Soundtrack list is very similar to the Layers list. The music files play in the order they appear, from top to bottom. If you want to change the order, click one of your music files, and click either the up or down arrow.

Click the music you have added. Notice that details about that track appear in the Track panel, just beneath the Soundtrack list (**Figure 3.30**).

The Track panel lets you configure options for a specific piece of music. At the top, you can see information about that music. Track Name is the actual name of the audio file. Track Type shows you the format, such as MP3 or OGG, of music file you are using, and Track Length tells you how long that track is.

Clicking the Edit Track button launches your audio-editing application, which you learned how to configure in Chapter 1.

When you adjust the Volume slider in the Track panel, you are changing the volume of that music track only. The same rules apply

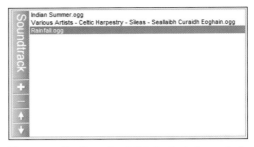

Figure 3.29 The Soundtrack list also includes controls for moving tracks up and down in order of playback, and for adding or deleting additional tracks.

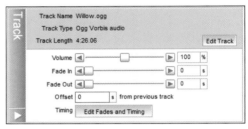

Figure 3.30 The Track panel shows details about your music and gives you options to configure just that track.

Figure 3.31 The Soundtrack Tools section gives you access to some great tools to even further customize your music.

Figure 3.32 You can import music from a CD with the Save Audio Track dialog.

Figure 3.33 Use the Track Info option to retrieve album information from the Internet and make song selection a little easier.

for the Fade In and Fade Out sliders. Move each slider to the left to decrease the value, and move it to the right to increase it.

This is great if you have a piece of music that is too quiet for your show. You can increase the volume of just that track without increasing the volume of the whole show at once.

The Offset value tells ProShow how long to wait before playing the music. If you enter **5**, ProShow will wait five seconds to start playing the track, either from the beginning of the show or from the end of the music that came before it.

The Edit Fades and Timing button launches the Audio Trimmer, which we'll cover in more detail in Chapter 6.

Using Soundtrack Tools

ProShow offers a few useful tools that you can use to work with your music in even more detail or to help automate some of the process.

The Soundtrack Tools section is located in the lower left of the Show Soundtrack tab and contains three buttons: Save Music From CD, Record Slide Timing, and Sync Slide to Audio (**Figure 3.31**).

Clicking the Save Music From CD button launches the Save Audio Track dialog (**Figure 3.32**). You can use this dialog to rip tracks from your audio CDs for use in your shows.

When you first open the Save Audio Track dialog, you may not see any meaningful names, just a listing of track numbers and lengths. Select the Track Info check box to download album and track titles from the Internet to make your music selection easier (**Figure 3.33**).

continues on next page

WORKING WITH MUSIC

Click the Save Music From CD button, and read the warning that appears (**Figure 3.34**). If you agree, click Yes.

The Save Audio Track dialog gives you the option to select a single song. To select a song, click the track you want to import (**Figure 3.35**).

Finally, if you want to add those tracks to your show automatically, make sure the Import box is selected, and click Save Track (**Figure 3.36**).

The Format option gives you the ability to choose what kind of audio file you want to create. By default, ProShow uses OGG, or Ogg Vorbis. You can also select MP3 if you prefer a more standard option.

Figure 3.34 You'll need to agree to the copyright warning before proceeding to copy music from a CD.

Figure 3.35 Getting audio from your CDs is easy with the Save Audio Track dialog.

Figure 3.36 Selecting the Import check box will not only convert your music but also add it to your show automatically.

Figure 3.37 After copying the music from the CD, ProShow will add it to your show and display the tracks in the Soundtrack list.

Figure 3.38 Clicking Sync Slide to Audio launches the synchronization options available in ProShow.

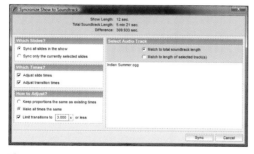

Figure 3.39 Using the Syncronize Show to Soundtrack options makes it easy to match your music to your slides. Click each of the options you want to use, and click Sync.

Figure 3.40 The Which Slides? options specify whether all slides or only the selected slides will be synchronized to the music.

Once you click Save Track, ProShow will rip the track from the CD and add it to your show for you (**Figure 3.37**).

The Sync Slide to Audio button in the Soundtrack Tools options (**Figure 3.38**) opens the Syncronize Show to Soundtrack dialog (**Figure 3.39**).

Using this dialog, you can synchronize your music to your show automatically, which can save a lot of time. You can decide exactly how you want ProShow to handle the synchronization, one option at a time.

The Which Slides? options let you choose whether you want to sync all slides in your show or just those you select (**Figure 3.40**). If you choose all slides, every slide will have its time changed to match the length of the audio. If you choose only selected slides, only the slides you pick will undergo a time change.

continues on next page

The Which Times? options let you choose whether ProShow will automatically adjust the slide times, the transition times, or both (**Figure 3.41**). If you have any effects that use specific transition or slide speeds, you can leave those out.

The How to Adjust? options tell ProShow how you want it to change the time of your slides (**Figure 3.42**). "Keep proportions the same as existing times" means that your slide will have the same time in proportion to others—essentially, that fast slides will still be fast when compared with other slides that may be slower.

"Make all times the same" directs ProShow to change all the slides equally, without regard to proportion. Finally, the "Limit transitions to _ seconds or less" check box prevents ProShow from automatically giving you really long transitions. It's set to three seconds by default.

In the last section, Select Audio Track, you can pick the audio track you want to use (**Figure 3.43**). The "Match to total soundtrack length" button will sync your entire list of music. If you want to sync only to a specific group of tracks, select the "Match to length of selected track(s)" option.

Figure 3.41 The Which Times? options specify whether all slide timing, transition timing, or both will be adjusted.

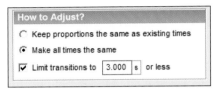

Figure 3.42 The How to Adjust? options control whether all slides play for the same duration or whether the timing adjustments will be proportional in length.

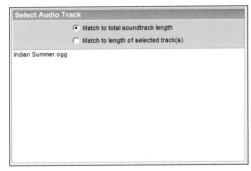

Figure 3.43 Select Audio Track lets you select the track to synchronize and whether the adjustment affects the total length or just a specific set of tracks.

WORKING WITH MUSIC

Figure 3.44 You can use Record Slide Timing to set the timing of your transitions while you listen to your music.

Once you have chosen all the options, click Sync, and ProShow will change your slide times so that the show ends right when your music ends.

Finally, the Record Slide Timing option allows you to listen to your music tracks and add transitions as you listen (**Figure 3.44**). This can be a great tool if you prefer to match a beat. For more information on Record Slide Timing, see Chapter 7.

✔ Tip

- It's generally a good idea to wait to sync your music until you have finished making all your slides. This is because ProShow syncs by changing the time of your slides. If you were to sync early and work more on your slides, the audio would fall out of sync, and you would have to repeat the step. Consider syncing the last step in making a show.

Applying Motion Effects

The feature that really gives you an edge in show creation is motion. Static images and audio are nice and can work in a slower-paced show, but the application of even subtle motion takes a simple show and adds a dynamic that your audience will love.

Using motion in ProShow is a very simple process designed to let you work as you watch so that you can see your changes immediately.

Essentially, you create motion by telling ProShow where you want a layer to start and where you want it to end. ProShow does the rest, making changes to the layer so that it does just what you direct it to do. All you have to do is decide what you want your slide to look like at the beginning and what you want it to look like when it ends.

Let's begin by looking at the motion effects and making some basic motion.

Adding Simple Motion Effects

Choose any slide you have created, and double-click it in the Slide List. This will open the Slide Options dialog.

Now, click the Effects tab and then the Motion Effects tab to open the Motion Effects dialog (**Figure 3.45**).

At the top of your Motion Effects tab are two preview panes. The pane on the left is your Starting Position pane. This is what your slide looks like at the beginning. The pane on the right is your Ending Position pane, which shows what your slide will look like at the end.

Before we go into any more detail, let's create some simple motion to see how it works. Drag your layer to the right of the slide in the Starting Position pane, and then drag the layer over to the left side of the slide in the Ending Position pane (**Figure 3.46**).

Figure 3.45 The Motion Effects tab is where you will make all your motion happen. Notice the two preview panes. These are for your starting and ending positions. ProShow creates motion by moving your slide from the starting to ending position.

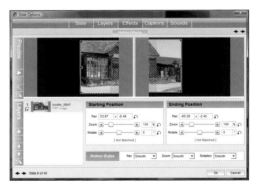

Figure 3.46 Creating motion is as simple as setting the starting and ending positions to different locations. You can create a straight or diagonal movement with very little effort. Here, your layer will move from the right side of the slide to the left.

Figure 3.47 The Preview panel is split into starting and ending position previews.

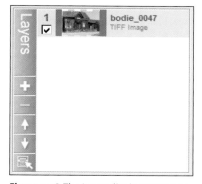

Figure 3.48 The Layers list is common to many of ProShow's dialogs.

Figure 3.49 The sliders and values in the Starting Position and Ending Position panes let you manually configure your motion.

Once you have moved the layer around in both panes, click the Play button ▶ to see what you have done. Notice that the layer moves from the starting position on the right side of the slide to the ending position on the left. That's all it takes to create motion—just set up the slides the way you want them to look at the beginning and the end of the motion. ProShow does the rest.

Now we'll look at the rest of the options in more detail. The two-pane Preview panel at the top of the screen has a few icons on the left side, which we will cover in Chapter 7 (**Figure 3.47**).

Beneath the Preview panes is a Layers list (**Figure 3.48**). This is the same type of Layers list that we covered earlier in the chapter and works in the same way.

The primary tools you will use for creating motion appear in the Starting Position and Ending Position panes (**Figure 3.49**).

Here, you can see that you have values for Pan, Zoom, and Rotate. Producer users also have a few additional options that will be covered in Chapter 4.

These values function here in the same way as when you are simply changing the appearance of a layer. Pan changes the position of the layer on the slide using X and Y values. Zoom changes the size of the layer. Rotate allows you to rotate the layer around.

You can change these values by manually entering a number or moving the slider. If you don't like the effect of a particular value, you can click the reset arrow.

APPLYING MOTION EFFECTS

Going Beyond Simple Motion Effects

Beneath the Starting Position and Ending Position panes is the Motion Styles panel (**Figure 3.50**). This tool tells ProShow how you want the layer to move, and each value has certain traits:

◆ Smooth is the default value, and this means that the layer's motion changes speed gradually, in a steady increase or decrease to give the appearance of smooth motion. It accelerates as it begins moving and decelerates before coming to a stop.

◆ Linear means that the layer moves at one speed, neither accelerating nor decelerating. This can appear abrupt.

◆ Accelerate means that the layer begins moving slowly but increases the speed of motion to full just before it comes to a stop.

◆ Decelerate means that the layer starts moving very fast but slows gradually until it comes to a stop.

You can configure each of these motion types for Pan, Zoom, or Rotation. It just depends on what style of motion you want.

Let's combine some motion styles to get a feel for how this works. Using the same slide, start by setting the Pan values in the Starting Position pane to 0 x 0 (**Figure 3.51**).

Figure 3.50 The Motion Styles drop-down lists control how your layers move for each motion type—Pan, Zoom, or Rotation.

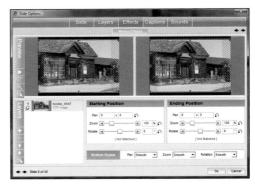

Figure 3.51 Start with the Pan value for the starting position set to 0 x 0.

APPLYING MOTION EFFECTS

Figure 3.52 With the Pan value set to 50 x 0, the image is moved to the right half of the Preview panel.

Figure 3.53 Reduce the Zoom value for the starting position to 0 percent.

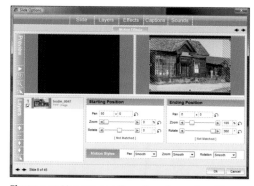

Figure 3.54 You can see the values for each setting used to create the motion. Try experimenting with your own values to see what you can create.

To create a zooming effect:

1. In the Starting Position pane, change the Pan value to 50 x 0. You should see the layer move to the right (**Figure 3.52**).

2. Now, change the Zoom value to 0 percent. This causes the layer to become so small that you can't see it (**Figure 3.53**).

3. In the Ending Position pane, set the Pan value to 0 x 0, the Zoom value to 100 percent, and the Rotate value to 360 (**Figure 3.54**).

continues on next page

APPLYING MOTION EFFECTS

This little effect will do a few things. First, you will see the layer zoom toward you and swoop sideways thanks to the Zoom and Pan values. While it does this, it will make a full rotation. **Figures 3.55** through **3.58** show this motion at several points during the playback of the slide.

You can combine all your motion effects to get a great-looking effect. Try experimenting with differences between the starting and ending positions to get a good feel for how motion is created.

✔ Tips

- Smooth motion style is the default option because it looks the most natural and refined. If you need another motion style, feel free to experiment, but always remember that it does change the way your layers appear to move.

- The fastest way to create motion, by far, is to work without manually changing values. You can drag your layer around in the Preview panes with your mouse, zoom using your mouse wheel, and rotate by clicking the blue triangular anchor on the right side of the layer. This makes it much easier to get the look you want.

Figure 3.55 At the start of the motion, the image is small and starting to rotate.

Figure 3.56 About a quarter of the way through the motion, the image continues to grow and rotate.

Figure 3.57 Three-quarters of the way through the motion.

Figure 3.58 As the motion nears the end, the transition to the next slide begins.

All About Keyframes

In Chapter 3, we covered how to create motion and control layers on your slides to produce a show that really comes to life. Now that you understand how to bring shows together with multiple layers, music, and motion, you can learn about keyframes.

Keyframes, available only in ProShow Producer, are the real magic behind Producer; they allow you to create all of the spectacular effects you see in advanced shows. The great thing about keyframes is that they work in just the same way as your other motion effects—with a starting position and an ending position. The difference is that you can have as many starting and ending positions on one slide as you want.

Let's begin by learning what keyframes are and how you create them.

Creating Keyframes

As you read a moment ago, a *keyframe* is basically a starting position and an ending position. Think about it this way: When you create motion using the method discussed in Chapter 3, you are telling ProShow to move the slide from one point to another. You are essentially traveling from point A to point B.

With keyframes, you can add more destinations to your slide. Rather than just going from point A to point B, you can now add a C, a D, or as many other points as you want.

Each one is controlled in the same way. You set up the way you want a layer to look in the starting position and the ending position, and then move on.

Exploring the Keyframe Options

Keyframes exist in three places in Producer—in Motion Effects, Adjustment Effects, and Caption Motion. We'll start with motion effects, since that's something you've already learned how to work with in Chapter 3.

To open the keyframe options:

1. Create a new slide by dragging an image into your Slide List.

2. Once you have the new slide created, double-click the new slide to open the Slide Options dialog.

3. Click the Effects tab and then the Motion Effects tab.

Now you're looking at the Motion Effects options in Producer (**Figure 4.1**). Notice that there are a few new tools available here compared with the Motion Effects options

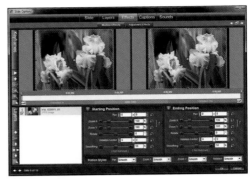

Figure 4.1 The Motion Effects dialog in Producer has a few additional tools compared with the options available in Gold—most important, the Keyframe Timeline. Also notice that you have a few more options for how you move your layers.

Figure 4.3 Keyframe markers are found at the top of the Keyframe Timeline, and every slide has one at the start and end by default.

Figure 4.4 Keyframes must appear in order, so each new keyframe takes the next number, while changing all of those after it. The keyframes originally marked 1 and 2 become 1 and 3, respectively, while 2 now appears in the middle.

you saw in Chapter 3. The Keyframe Timeline is the main addition, and this is what you will use to control all of your keyframe activity on a slide (**Figure 4.2**, below).

Now let's focus on the keyframes themselves. At the top-left and top-right corners of the Keyframe Timeline, you'll see shield icons labeled 1 and 2; these are your keyframes. Every slide you create will start at 1 and end at 2. One will be at the start of the transition in, and the other will be at the end of the transition out (**Figure 4.3**).

In short, these are your starting and ending positions. These are called *keyframe markers* or, simply, *keyframes*.

Now that you're familiar with the Keyframe Timeline, let's get started by adding a new keyframe. To begin, click the Add Keyframe button on the left side of the Keyframes panel.

When you add a new keyframe, take notice of a few things. The new keyframe appears right in the middle of your Keyframe Timeline and has been assigned the number 2. The keyframe at the end is now labeled 3 (**Figure 4.4**).

✔ Tip

- The Keyframe Timeline shows you everything about your slide timing. If you want to check your slide setup at a glance, just look at the time values and shaded regions on the Keyframe Timeline.

Figure 4.2 Here you see the Keyframe Timeline. Notice that it displays the time at the top of the timeline and the time segments at the bottom. The Transition In time shows when your slide will begin transitioning into display. The shaded Slide Time area indicates when the slide is displayed in full, and the Transition Out time indicates when your slide will begin transitioning out for the next slide.

CREATING KEYFRAMES

Motion Effects with Keyframes

You have three keyframes to work with at this point, so let's create some motion and get a feel for how they function.

This should be a refresher of Chapter 3. You can set up your motion one keyframe at a time. Start by clicking in the space between keyframes 1 and 2 on your Keyframe Timeline. You will see those two markers highlighted in blue, with a blue shaded region between them (**Figure 4.5**). This means they are selected.

There's one last thing to look at before you set up motion. Immediately underneath the Keyframe Timeline, you will see that each of the preview panes has been labeled. The left pane is Keyframe 1 (Starting Position), and the right pane is Keyframe 2. This just reinforces that you have selected the pair (**Figure 4.6**).

To create motion with keyframes:

1. In the left pane for keyframe 1, zoom in on the layer to about 130 percent (**Figure 4.7**).

2. Move the layer to the right so that the right marker is at the right edge of the slide (**Figure 4.8**).

 Keyframe 1, our starting position, is set up. Let's get keyframe 2 arranged.

Figure 4.5 Editing the movement for each keyframe is done by selecting pairs of markers. Here, keyframe pair 1 and 2 is selected, as shown by the blue shading.

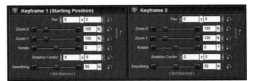

Figure 4.6 The label at the top of each settings panel (underneath the Keyframe Timeline) indicates which pair you have selected. This helps ensure that you're working with the correct pair.

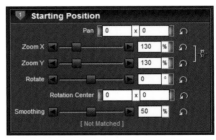

Figure 4.7 Start by setting the Zoom values for keyframe 1 to 130 percent.

Figure 4.8 Move the layer to the right, lining up the right marker to the right edge of the slide.

Figure 4.9 Here you can see the first two keyframes configured and ready to go.

Figure 4.10 Select keyframe 3 by clicking the area between the keyframe 2 and 3 markers in the Keyframe Timeline.

3. Drag the layer to around the center of the slide in the right preview pane. This will center it on the slide again. Change the Zoom values to 115 percent (**Figure 4.9**).

The last piece to setting the motion for this slide is configuring keyframe 3, and this process is just as simple as the previous two.

To configure keyframe 3:

1. Click the space between keyframes 2 and 3 on the Keyframe Timeline. Keyframes 2 and 3 will now be selected with the blue shading between them. Notice that keyframe 2 is already set up, but it appears in the left pane. All you need to focus on is keyframe 3 (**Figure 4.10**).

continues on next page

2. In the right pane, keyframe 3, start by changing the Pan values to -20 x 0. This moves the keyframe to the left. Change the Zoom values to 0 percent (**Figure 4.11**), to make the layer as small as possible. In **Figure 4.12**, you can see the adjustments made so far.

Now that the motion has been prepared for all three keyframes, click the Play button 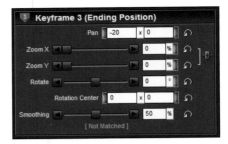 to preview what you have made.

You will see the layer pan to the left and zoom out slightly, and then zoom dramatically away from you once it reaches keyframe 2. As you can see, the process involves a simple step to what you already know. Instead of moving from A to B, you move from A to B to C.

Figure 4.11 Keyframes 2 and 3 are all set up, and you can see the values that were changed here.

Figure 4.12 After you set the values for keyframe 3, the dialog should look similar to this.

Figure 4.13 To change the speed of the motion effect, move the keyframe 2 marker to the left in the Keyframe Timeline. In this example, I've moved it to the one-second mark.

Adjusting Keyframe Timing

Controlling how your layers move using keyframes is just one part of the process. The other major piece of keyframing is the speed and timing that your layers will use to move around the slide.

Think about speed this way: ProShow handles the actual motion for you automatically, so it happens as fast or as slowly as you allow.

The example you just completed is a good demonstration of this. If you use the default slide times, you have six seconds for the full motion effect—three seconds for the slide itself and three seconds for the transition. If you want to speed up the motion—that is, make the layer move faster—you need to give ProShow less time.

This is where keyframe timing adjustment comes in. By changing the timing of keyframes, you can speed up or slow down motion, as well as coordinate motion between multiple layers. You'll look at that in more detail later in this chapter in the "Adding Multilayer Effects" section.

To change keyframe times:

1. Return to the slide you created a moment ago. Double-click the slide, and select the Effects tab and then choose the Motion Effects tab. Now that you have the motion options open, let's increase the speed of the motion effect:

2. Start by dragging the keyframe 2 marker at the top of the Keyframe Timeline to the left. Place it at one second on the timeline (**Figure 4.13**).

continues on next page

3. Now, do the same for keyframe 3. Drag the marker to the left so that it is placed right at the end of the Slide Time shaded area at the bottom of the timeline. This should be at three seconds (**Figure 4.14**).

4. Once the keyframes have been moved, click Play ▶ to preview your effect. The movement should happen much faster, and a blank slide will appear during the transition period. As you can see, the less time a motion has, the faster it takes place.

You can perform the opposite steps to slow something down. Give your keyframes more time, and the effect takes place more slowly.

There is another important piece of keyframing to note here. When you reach the last keyframe for a layer, in this case keyframe 3, the layer is no longer visible. You can control when layers appear and vanish on a slide by setting up where the first keyframe and last keyframe are placed. The rule is simple—a layer must have a keyframe in order to be displayed. If it runs out of keyframes, it's effectively gone (**Figure 4.15**).

Adjusting your keyframe times by dragging the keyframe is the easiest visual way to make changes, but when you want to time your keyframes with precise values, you can set each keyframe exactly.

The best way to do this is to right-click the keyframe marker you want to move. A contextual menu will appear with a few options (**Figure 4.16**).

Figure 4.14 The adjusted keyframes, which you can move by simply dragging them to the left on the timeline, are shown here.

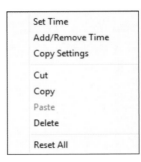

Figure 4.15 The last keyframe for the layer, shown here, is where the layer effectively "ends." It does not appear for the rest of the time remaining on the slide.

Figure 4.16 The contextual menu that appears when you right-click a keyframe marker gives you a variety of options. Most important here is the Set Time option.

Figure 4.17 The Set Time option will let you enter an exact time for your keyframe to give you complete control.

Figure 4.18 After you enter the new time, your keyframe timing will be set to this exact value.

Figure 4.19 Set the timing for keyframe 3 to three seconds.

Figure 4.20 The Add/Remove Time option allows you to change the timing of a keyframe, adding or removing time from the end of a keyframe.

To make precise keyframe adjustments:

1. Choose Set Time, and you will see a dialog that asks you to enter the exact time you want to use. If you want to make sure that keyframe 2 is set at exactly one second, you can do so using this method (**Figure 4.17**).

2. Right-click keyframe 2, choose Set Time, enter **1**, and click OK. Keyframe 2 will now be set to exactly one second (**Figure 4.18**).

3. Do the same for keyframe 3. Right-click keyframe 3, choose Set Time, enter **3**, and click OK (**Figure 4.19**). Now both of your keyframes are set to precise times.

You have two timing adjustment options when you right-click a keyframe:

◆ Set Time, which allows you to enter a specific time in seconds. This will place the keyframe at that time.

◆ Add/Remove Time, which allows you to enter a number in seconds to add time to the keyframe (**Figure 4.20**). For example, if you were to enter **1** for keyframe 2, it would gain a second and be placed at two seconds. If you want to remove time, enter a negative number, such as **-1**.

✔ Tip

■ Remember that keyframes must always appear in the correct order. Keyframe 1 must always be before 2. If you try to adjust a keyframe so that it appears before the keyframe ahead of it in the order, Producer will not let you do so.

ADJUSTING KEYFRAME TIMING

Adding Multilayer Effects

Creating keyframes and adjusting their timing are all you need to know how to do to fully take advantage of them. Now that you're familiar with using keyframes, you'll learn how to add multiple layers.

Using additional layers doesn't make keyframes any more difficult to use. You still create keyframes, set up what you want your layer to do, and arrange their time values. When working with multiple layers, you just take one layer at a time.

Using Keyframes with Layers

Before you dive in and start adding layers, you need to understand how layers and keyframes work together.

The most important point is that every layer has its own keyframes. This means that you set up the keyframes for every layer you add to a slide, individually. One layer could have four keyframes, while another might have only two.

Because every layer has its own keyframes, you never have to worry about changes to the keyframes on one layer causing problems for another. They all exist in their own vacuums.

Creating a Multilayer Keyframe Effect

We'll jump right in by creating a new slide that uses three layers to create an interesting effect that combines pan and zoom. This will also illustrate how you can control when layers are visible.

Figure 4.21 Drag additional images onto the slide by holding down the Control key while dragging and dropping the image on the slide.

Figure 4.22 After you drag the additional images onto the slide, the thumbnail will show one image, but you'll see a stack icon added to the slide.

Figure 4.23 The new slide shows a time value of six seconds. The slide now contains three layers, though only one appears in the thumbnail.

Figure 4.24 With the Motion Effects tab selected, click layer 1 to begin defining the motion for the layer.

If you still have the options dialog open, go ahead and close it. Let's start with a new slide and go from there:

To adjust layer 1:

1. Create a new slide by dragging an image from the File List to the Slide List.

2. Now add some layers to the new slide. Choose another image from the File List, hold down Control on the keyboard, and drag it onto the slide you just created (**Figure 4.21**).

3. Do the same with a third image. Now you should have three layers on the new slide. You'll see only one in the thumbnail (**Figure 4.22**), but the slide will display a stack icon in the Slide List.

4. Let's change the time of the slide to something you can work with. Set the slide to six seconds by clicking the time value underneath the thumbnail and entering **6** (**Figure 4.23**).

 Now you can begin setting up the motion for each layer. The easiest way to do this is to complete one layer at a time and have a plan in mind when you get started for how you'd like each layer motion to look.

5. Double-click the new slide, and select the Effects tab and then choose the Motion Effects tab. Select layer 1 in the Layers list (**Figure 4.24**).

 For this motion effect, you'll zoom in on layer 1 to 0 percent on the left side of the slide, pan right and zoom in to fill the slide, and then zoom out again to 0 percent on the right side of the slide. This step will take three keyframes.

continues on next page

ADDING MULTILAYER EFFECTS

6. Click the Add button to create a new keyframe, which will appear in the middle of the Keyframe Timeline as keyframe 2 (**Figure 4.25**).

7. Now you can set up the motion. Select keyframe pair 1 and 2, and in the left pane, change the Zoom values to 0 percent. Then move the layer to the left side of the slide (**Figure 4.26**).

8. In the right pane, the keyframe 2 position, recenter the layer on the slide, and change the Zoom values until it fills the slide frame (**Figure 4.27**).

Figure 4.25 Click the Add button to add a keyframe to the layer.

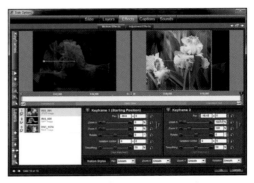

Figure 4.26 Adjust keyframe 1 to a zoom of 0 percent, and drag the layer to the left side of the slide.

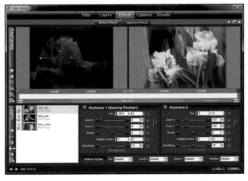

Figure 4.27 You can see that layer 1 is zoomed to 0 percent to start keyframe 1, moved to the left in the left pane to end the keyframe and begin keyframe 2, and centered with Zoom values of 107 percent in the right pane.

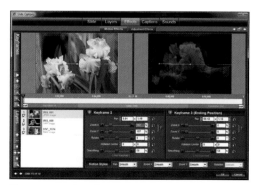

Figure 4.28 Select keyframe pair 2 and 3 by clicking the Keyframe Timeline between those frames. Change the zoom and position of the right, or ending, position.

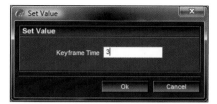

Figure 4.29 Set the time of keyframe 1 by choosing the Set Time option and entering 3 as the value.

Figure 4.30 Set keyframe 2 to four seconds.

9. Select keyframe pair 2 and 3 by clicking the space between them in the Keyframe Timeline. In the right pane, or keyframe 3 position, change the Zoom values for the layer to 0 percent, and move it to the right side of the slide (**Figure 4.28**).

Click the Play button to see what you have so far. You should see the layer zoom in and pan until it reaches the center of the slide and then begin to zoom out until it's no longer visible on the right side.

The last step in adding motion to this layer is setting the timing for the keyframes. You want all three layers to quickly come and go during this effect, so you need to make this move fast enough to give room for the others.

The slide time is set to six seconds and you have three layers, so a total time of two seconds for each layer should be nice and even.

10. Right-click keyframe 1, and choose Set Time. Change the value to three seconds, which should be the start of the Slide Time area (**Figure 4.29**).

11. Right-click keyframe 2, and choose Set Time. Set this to four seconds, which will be the middle of our motion (**Figure 4.30**).

continues on next page

ADDING MULTILAYER EFFECTS

12. Finally, right-click keyframe 3, and choose Set Time. Set keyframe 3 to five seconds (**Figure 4.31**), which will give you a two-second period from three to five seconds for all three keyframes (**Figure 4.32**).

Click the Play button to make sure your effect is moving nice and fast. Now that this is done, you can begin setting up the other two layers (**Figure 4.33**).

Layer 2 is now ready to configure. You'll start layer 2 on the right side of the slide, where layer 1 disappeared. From there, you'll do the same thing, panning and zooming across the center of the slide, as you did with layer 1.

To adjust layer 2:

1. Select layer 2 in the Layers list, and click the Add button. You will have three keyframes, spread across the slide time (**Figure 4.34**).

Figure 4.31 The timing for keyframe 3 is set to five seconds.

Figure 4.32 After you set all the keyframes for layer 1, the motion will occur between the three- and five-second marks of the slide.

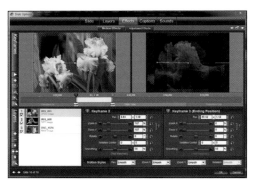

Figure 4.33 Here is the completed set of three keyframes, with the timing that you created in the previous steps. This will make the layer move quickly through the motions set up for it.

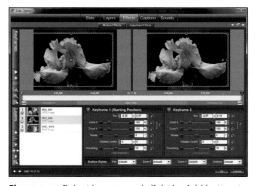

Figure 4.34 Select layer 2, and click the Add button to add another keyframe.

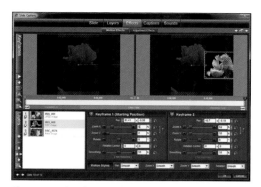

Figure 4.35 Set the starting position to the right side of the slide, and change the zoom to 0 percent.

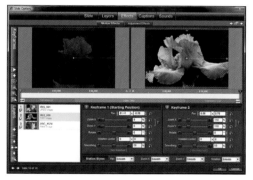

Figure 4.36 Position the right side, or keyframe 2, to the center of the slide, and zoom to fill the slide.

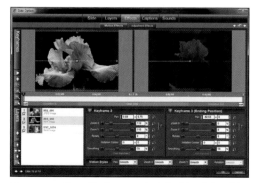

Figure 4.37 Move the layer to the left side of the slide, and set the Zoom values to 0 percent for keyframe 3.

2. Select keyframe pair 1 and 2. In the left, starting pane, change the Zoom values to 0 percent and position the layer on the right side of the slide (**Figure 4.35**).

3. In the right pane, or keyframe 2 position, move the layer back to the center of the slide, and zoom in until it fills the slide frame (**Figure 4.36**).

4. Select keyframe pair 2 and 3. In the right pane, or keyframe 3 position, change the layer zoom back to 0 percent, and move it to the left side of the slide (**Figure 4.37**).

continues on next page

5. All you have left to do is adjust the timing. Right-click keyframe 1, and choose Set Time. You want keyframe 1 to start immediately after the last keyframe for layer 1 ends. If you recall, this was at five seconds. So, set keyframe 1 for layer 2 to five seconds (**Figure 4.38**).

6. Keyframe 2 should already be set to six seconds, so right-click keyframe 3, choose Set Time, and set it to seven seconds (**Figure 4.39**).

You now have layer 2 set to begin its motion as soon as layer 1 is finished (**Figure 4.40**).

Figure 4.38 This layer should start its motion as soon as layer 1 finishes. Set the time value for keyframe 1 to five seconds, which is the ending time of layer 1.

Figure 4.39 Keyframe 3 time is set to seven seconds. This keeps the timing the same as you have in layer 1, but starting at five seconds and ending at seven seconds.

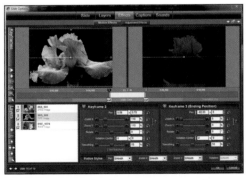

Figure 4.40 Layer 2 has been set up to move in the opposite direction of layer 1. It also uses three keyframes, timed to start as soon as layer 1 ends.

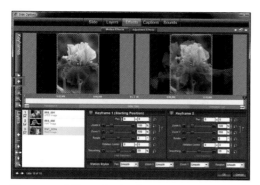

Figure 4.41 Add another keyframe to layer 3 by clicking the Add button.

Figure 4.42 Move the keyframe 1 starting position to the left of the slide, and set the Zoom values to 0 percent.

Figure 4.43 Set the keyframe 2 (in the lower-right pane) back to the center of the slide, and zoom to fill the frame.

For the final piece of the effect, you need to set layer 3 to begin moving in the same way as layer 1, starting when layer 2 ends at seven seconds.

To adjust layer 3:

1. Click layer 3 in the Layers list. Click the Add button to prepare three keyframes for the effect (**Figure 4.41**).

2. Select keyframe pair 1 and 2. In the left pane, or keyframe 1, change the Zoom values for the layer to 0 percent, and position it on the left side of the slide frame (**Figure 4.42**).

3. In the right pane, or keyframe 2, position the layer back in the center of the slide, and increase the Zoom values until it fills the slide frame (**Figure 4.43**).

continues on next page

ADDING MULTILAYER EFFECTS

69

4. Select keyframe pair 2 and 3. In the right pane, or keyframe 3, change the Zoom values to 0 percent, and position the layer on the right side of the slide frame (**Figure 4.44**).

5. The timing is all that's left. Right-click keyframe 2, and choose Set Time. Change the value to eight seconds. You're starting with keyframe 2 this time because it must be moved back to make room to adjust keyframe 1 (**Figure 4.45**).

6. Right-click keyframe 1, and choose Set Time. Change the value to seven seconds (**Figure 4.46**), which is when the last keyframe for layer 2 ended. Finally, right-click keyframe 3, choose Set Time, and enter **9** for nine seconds (**Figure 4.47**). **Figure 4.48** shows the completed keyframe adjustments for the slide.

Figure 4.44 Select keyframe pair 2 and 3, and then position the layer on the right side of the slide with Zoom values of 0 percent.

Figure 4.45 To adjust the timing for the final layer, you start with keyframe 2 and set the value to eight seconds.

Figure 4.46 Set the time value for keyframe 1 to seven seconds. This will start the motion as soon as layer 2 is completed.

Figure 4.47 Set the time value for keyframe 3 to nine seconds, giving it the same duration as the other two layers on the slide.

Figure 4.48 The last pieces of the effect, the settings for layer 3, are complete, and the slide is ready to go, with motion for each layer beginning at the end of the previous layer motion settings.

Click the Play button again to see your final motion effect. You should see layer 1 move across the screen from left to right, zooming in and out. Just as layer 1 ends, layer 2 will perform the same movement in the opposite direction. This will repeat with layer 3 to close the effect.

This dynamic effect is a great way to show off your knowledge of keyframes. That's all there is to using keyframes to create motion and harnessing what you can do with layers.

Exploring the Keyframe Editor

When you begin working with multiple layers and adding precision keyframe timing, the Keyframe Editor becomes incredibly valuable.

Using the Keyframe Editor, you can see all layers and keyframes on your slide at one time. Let's use the slide you have just created as an example of what you can do with the Keyframe Editor.

Opening the Keyframe Editor

You can open the Keyframe Editor by clicking the Keyframe Editor button in the Keyframes pane of the Motion Effects, Adjustment Effects, or Caption Motion tab.

Click the Keyframe Editor button to get started. This opens the Keyframe Editor dialog, which features a preview panel and a list of layers on the right (**Figure 4.49**).

The Keyframe Editor dialog displays all the layers on your slide, as well as captions. Each one shows all keyframes and timing so that you can get your entire slide at a glance without switching between multiple layers.

This is a great way to make sure that your timing is correct and that the keyframes are arranged in the way you want them to appear.

Using the Keyframe Editor

On the left side of the Keyframe Editor is your preview panel and some basic controls:

◆ Play starts playing your slide as it is currently set up. You will see how everything works and get a quick preview this way (**Figure 4.50**).

Figure 4.49 The Keyframe Editor features a preview panel and a list of all layers, each of which shows a Keyframe Timeline and associated keyframes.

Figure 4.50 Use the Play button to preview your motion effects.

Figure 4.51 The Editor Zoom slider enables you to get a closer look at the timing of your keyframes.

Figure 4.52 KeyFrame Time works like the Set Time option. Select a keyframe marker, click Set Time to open the dialog, and enter the new time.

Figure 4.53 You can quickly get a look at how your keyframes line up and are timed by using the Keyframe Editor.

◆ The Editor Zoom slider (**Figure 4.51**) increases or decreases the zoom of your Keyframe Timelines on the right. Drag the slider left to decrease the zoom, and drag it to the right to increase the zoom.

◆ Keyframe Time (**Figure 4.52**) works just like right-clicking a keyframe and choosing Set Time. Click the keyframe marker you want to move, click Set Time, and enter the value.

◆ Keyframe Selection allows you to quickly deselect any keyframes you have been working with.

◆ Close simply closes the Keyframe Editor dialog.

Look at the editor list on the right side of the window. Here you can see your three layers, in order. Each layer has a full Keyframe Timeline, showing all the same information as the normal Keyframe Timeline. You can see each keyframe, the time markers at the top, and the section shading at the bottom.

Working with keyframes in the Keyframe Editor is just like using them on the Keyframe Timeline. You can select keyframes, drag them to adjust time, or right-click them to set the time to whatever value you want.

The benefit of the Keyframe Editor comes from the ability to see all your keyframes at once. Notice here that you can see how your keyframes all line up. Keyframe 1 in layer 2 starts right where keyframe 3 ends in layer 1. The same is true for layers 2 and 3. You can tell, just by looking, that your keyframes have been placed properly (**Figure 4.53**).

EXPLORING THE KEYFRAME EDITOR

Selecting Multiple Keyframes

The Keyframe Editor gives you the ability to work with more than one keyframe at a time. If you want to move a group of keyframes around at once, you can lasso to select as many as you like.

To select keyframes using a lasso:

1. Click anywhere in the editor pane, and drag your pointer. You will see it create a selection box, or *lasso*, which highlights the selection (**Figure 4.54**). Every keyframe that is inside your lasso when you release the mouse will be selected.

2. Try dragging a lasso around keyframe 1 in both layer 1 and layer 2 (**Figure 4.55**). The selected keyframe markers are now in blue.

3. Once you have done this, right-click keyframe 1 in layer 1.

4. Choose Align Selected Keyframes Here (**Figure 4.56**). This will automatically match both keyframes you have selected to the same place (**Figure 4.57**).

This is a great shortcut to make sure that your keyframes all line up and are properly timed.

Remember, you can find examples of keyframe use on the companion Web site at *www.proshowbook.com/chapter4.*

✔ Tip

- Try re-creating the three-layer example, but don't adjust the keyframe times. Instead, finish all the motion and then use the Keyframe Editor to make your timing adjustments. You may find this to be an easier and faster way to get your effects finalized.

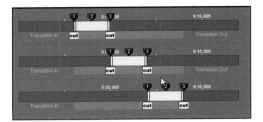

Figure 4.54 Drag the pointer to select multiple keyframes in the Keyframe Editor.

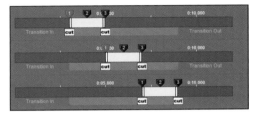

Figure 4.55 Click and drag to select keyframe 1 in both layer 1 and layer 2. The selected keyframe markers will be in blue.

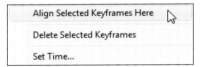

Figure 4.56 Right-click keyframe 1, and choose Align Selected Keyframes Here.

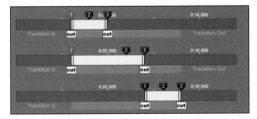

Figure 4.57 After you choose Align Selected Keyframes Here, the two selected keyframes now have the same starting time.

EDITING
IMAGES IN PROSHOW

5

ProShow doesn't force you to use your images as is, with all adjustments done prior to importing them into a show. Along with offering the ability to link to an external editing program such as Adobe Photoshop for images or Adobe Premiere Pro for video, ProShow allows you to do a number of image-editing tasks directly within the program, thanks to its robust set of tools.

ProShow Producer offers even more control over your images with the ability to add masks, adjustment layers, vignettes, and transparency effects.

Image Adjustments

Both versions of ProShow include basic adjustment tools such as brightness, contrast, hue, and sharpening. In this section, you'll take a look at each of these individually.

Adjusting Brightness

Sometimes your image is too bright or too dark for optimal display in your show. To correct this, use the Brightness control (**Figure 5.1**).

To access the adjustment options, double-click the slide you want to edit, or click the Slide button in the toolbar.

With the Layers tab selected, choose the Editing tab. To increase the brightness of the selected slide, move the Brightness slider to the right. Clicking the end arrows increases the adjustment by 1 percent. In the example shown in **Figure 5.2**, I've increased the brightness by 42 percent, which has opened up the shadows considerably.

To darken the image, move the Brightness slider to the left. In the example shown in **Figure 5.3**, I've decreased the brightness by 10 percent, which has given me more detail in the lighter areas of the image.

ProShow provides a before and after preview of your editing in the lower-right corner of the Slide Options dialog. If you decide the image needs more adjustment than you can perform in ProShow, clicking Edit will launch the external editor (see "Using External Editors" later in this chapter) with the selected image open.

✔ Tip

■ Positioning the Slide Options dialog so that the Preview panel is visible will let you easily see how your adjustments are affecting the image.

Figure 5.1 The Brightness control lets you adjust the overall brightness for your image.

Figure 5.2 Use positive adjustments to the Brightness control to open up shadow detail in your image.

Figure 5.3 Negative Brightness settings give you more detail in the lighter areas of the image.

IMAGE ADJUSTMENTS

Figure 5.4 The White Point control determines where the highlight tones turn to white with no detail.

Figure 5.5 Higher White Point settings make the image lighter and move the point to where the highlights become pure white.

Figure 5.6 Lower White Point settings will reduce the highlights in your image.

Adjusting White Point

White Point sets the brightest point in the image by determining where the image tones go pure white (**Figure 5.4**).

To increase the White Point setting, move the slider to the right by dragging the control handle or by clicking the right arrow. You can also increase the setting by entering a number directly into the field to the right of the control (**Figure 5.5**).

To decrease the White Point setting, move the slider to the left (**Figure 5.6**). This will adjust the brightest point down, reducing the highlights.

Adjusting Black Point

Black Point sets the darkest point in the image by determining where the image tones go pure black (**Figure 5.7**).

This is useful for adjusting images with shadow detail that you want to enhance by either building density or lightening to show more details.

To increase the Black Point setting and lighten the shadows, move the slider to the right by either clicking the right arrow or dragging the control handle to the right. You can also enter a value directly into the field to the right of the control (**Figure 5.8**).

To decrease the Black Point setting and increase the density of shadows, move the slider to the left (**Figure 5.9**). The overall image will become darker.

Figure 5.7 Use Black Point to adjust the darkest point in your image.

Figure 5.8 A positive setting for Black Point lightens the shadows in your image.

Figure 5.9 Lower settings on the Black Point control darken the image.

Figure 5.10 Use the Auto button to set all three controls automatically, based on how ProShow evaluates the image.

Figure 5.11 After using the Auto button, you can fine-tune the adjustments if needed.

Figure 5.12 You can use the Contrast control to increase or reduce the differences between light and dark areas in your image.

You can also make changes to Brightness, White Point, and Black Point in one operation by clicking the Auto button (**Figure 5.10**). Auto will examine your image and determine how much adjustment, if any, each of these three controls needs.

You might need to fine-tune the adjustment (I find that it often adds too much White Point, causing a loss of highlight detail). If you don't like the results, just click the undo button next to each adjustment (**Figure 5.11**).

Adjusting Contrast

The Contrast control increases or reduces the difference between light and dark in your images (**Figure 5.12**). Higher settings will enhance the differences, while lower settings will reduce the contrast, giving the image a flatter look.

continues on next page

IMAGE ADJUSTMENTS

To increase the contrast in your image, drag the control handle to the right, or click the right arrow to increase the contrast by 1 percent with each click. You can also enter a value directly in the edit field (**Figure 5.13**).

To decrease the contrast, giving the image a flatter look, adjust the slider to the left (**Figure 5.14**). This lowers the difference between light and dark in your image, giving it more of a washed-out effect.

Adjusting Hue

Hue changes the overall color tone of the image. Although this might not sound all that practical, you can use the Hue control to great effect when applying it to layers (**Figure 5.15**).

You can keep a version of an image with a different hue in each layer. Adjusting the motion to bring the image layers into alignment can create an interesting effect.

✔ Tip

■ You can find an example of this technique on the companion Web site in the Chapter 5 samples.

Figure 5.13 Positive adjustments to Contrast enhance the differences between light and dark values.

Figure 5.14 Negative Contrast settings reduce contrast, giving the image a flatter look.

Figure 5.15 The Hue control is useful when you want to create special color effects in your images.

Figure 5.16 As you adjust the Hue control, you'll see all the colors shift in your image.

To adjust the hue of your image, drag the control handle to the desired hue, or click the arrow button to change the hue by 1 percent with each click. I find that when using the Hue control on layers, an increase of 25 percent is a good setting (**Figure 5.16**).

Figure 5.17 shows the different hues that result with a 25 percent hue increase on each layer.

Hue +25%

Hue +50%

Hue +75%

Hue +100%

Figure 5.17 I use the Hue control with multiple-layer slides. In this example, I've used 25 percent, 50 percent, 75 percent, and 100 percent.

Adjusting Sharpness

The Sharpen control works by enhancing the edges in your image, giving the appearance of more definition in these areas (**Figure 5.18**).

You need to be careful with adjustments to the Sharpen setting because it's easy to oversharpen your image and give it a very unnatural look. I find that I seldom need to apply more than 10 percent sharpening, and I use it only when there are fine details in the image (**Figure 5.19**). For images that contain people, I do not use sharpen at all.

✔ Tip

■ For all of these adjustments, you can quickly reset the control to the default by clicking the undo icon ⟲.

Figure 5.18 Sharpen can be useful to enhance edge detail but needs to be used carefully to avoid creating artifacts in your image.

Figure 5.19 After I added 8 points of sharpening, the image contained enhanced edge detail.

Figure 5.20 ProShow allows you to rotate and flip images, which is useful when the file is imported in the wrong orientation.

Figure 5.21 The Rotate control can rotate your image in 90-degree increments.

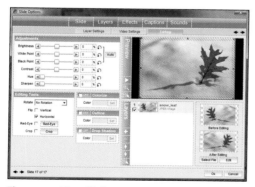

Figure 5.22 Flip will give you a mirror image of your original file.

Using Rotate and Flip

ProShow can rotate and flip your images, which is useful if the image is in the wrong orientation when imported into your show (**Figure 5.20**).

To rotate an image, click the Rotate drop-down menu in the Editing Tools section, and choose one of the preset values. In **Figure 5.21**, I've rotated the image 180 degrees.

Flip Vertical and Flip Horizontal give you a mirror image in the direction you select. In the example shown in **Figure 5.22**, I've used Flip Horizontal to reverse the leaf in the slide.

✔ Tip

- While the Rotate options in the Layer > Editing panel are fixed, you can create custom rotation amounts in the Motion Effects panel. See Chapter 3 for full details on this.

IMAGE ADJUSTMENTS

Correcting Red-Eye

The Red-Eye control easily corrects the red-eye problem that commonly occurs with many compact cameras that use a flash (**Figure 5.23**). For the red-eye adjustment to be applied, you must have the Red-Eye check box selected.

To remove red-eye, click the Red-Eye button to open the Red-Eye dialog. Using your mouse wheel, zoom in on the image for a better view of the problem area. You can use the right mouse button to pan around the image to bring the red-eye into view if needed (**Figure 5.24**).

Now, click and drag to define the area you want to adjust (**Figure 5.25**). You can resize the selection by dragging one of the handles.

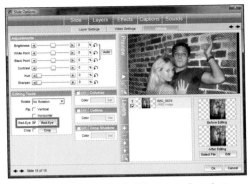

Figure 5.23 To access the Red-Eye controls, select the Red-Eye check box. The adjustments will not be applied unless this check box is selected.

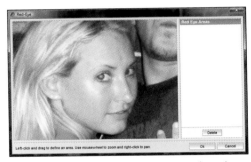

Figure 5.24 Zoom in on your image to see the red-eye more clearly.

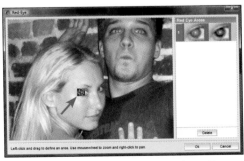

Figure 5.25 Drag a selection over the red-eye. The control works by desaturating the color under the selection.

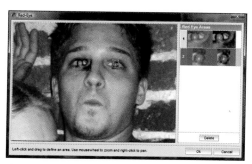

Figure 5.26 Be careful to select only the red portion of the eye in order to avoid this type of problem.

The selected area should be only large enough to contain the red-eye. Because this adjustment works by *desaturating*, or removing the color, from the selected area, a sloppy selection will lead to unwanted changes to the image (**Figure 5.26**).

Repeat your selection for each eye that needs adjustment. If you make a mistake, select the adjustment from the list and either modify it or delete it completely by clicking Delete (**Figure 5.27**).

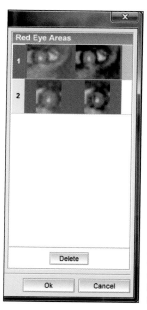

Figure 5.27 You can delete a red-eye correction by selecting it in the list and clicking Delete.

Cropping Images

The Crop control enables you to trim out unwanted portions of the image from within ProShow (**Figure 5.28**).

To begin, select the Crop check box, and click the Crop button. This will open the Crop dialog (**Figure 5.29**). This dialog has controls for both the size and the position of the crop, as well as the rotation for the crop.

Rather than entering values directly into the edit fields for the size and crop location, it's much easier to drag a selection rectangle to set the size of your crop (**Figure 5.30**).

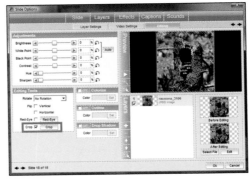

Figure 5.28 To open the Crop dialog, click the Crop button. Your crop will not be applied unless you've selected the Crop check box.

Figure 5.29 The Crop dialog has all the options needed to crop and rotate your image.

Figure 5.30 Although you can enter size and location values directly for crops, it's much easier to drag a selection with the pointer.

Figure 5.31 You can drag the crop selection handles to resize the crop or move the crop to a new area to fine-tune your selection.

Figure 5.32 After rotating to the desired angle, drag a crop rectangle to crop to that size.

Figure 5.33 After you use the Crop tool with the rotation option, the image is updated on the slide.

Begin by selecting one of the corners for your new crop and drag to the opposite corner. If you need to fine-tune the selection, you can use the resize handles to change the size, or you can drag the selection to a new location to change where the crop will be done (**Figure 5.31**).

To rotate the crop, you must first rotate the image by using the Rotate slider. You can drag the control handle or click the direction arrows to rotate 1 degree for each click. Alternatively, you can enter a number directly into the degree field. ProShow will rotate the entire image. When you have the image at the desired rotation, drag a crop to set that as the new image area selection (**Figure 5.32**).

The finished image (**Figure 5.33**) is now cropped and rotated.

IMAGE ADJUSTMENTS

Colorizing Images

Use the Colorize control to convert your image to a monochromatic look with a color tint (**Figure 5.34**). Sepia tone is a good example of this.

To use the Colorize control, select the On/Off toggle box. This will convert your image to grayscale (**Figure 5.35**).

To give the image a color tint, click the Set button to open the color picker (**Figure 5.36**). Click the outer ring to set the color hue, and click in the triangle to set the color saturation.

You can also use the eyedropper to click a specific color value or enter color values directly as RGB or hex color numbers (**Figure 5.37**).

Once you've selected the color you want to use, click the Set Color button to apply the change. If you change your mind, you can click the Cancel button to dismiss the color picker without making any changes.

✔ Tip

■ The eyedropper lets you select from any visible color on your monitor—even the desktop or an icon. Although you won't see the eyedropper when you move beyond the ProShow window, anywhere you click will be registered as the new color value for the Colorize control.

Figure 5.34 Use the Colorize control to give your images a toned monochromatic look, as in the old sepia images.

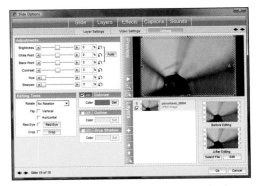

Figure 5.35 Enable the Colorize control by selecting the Off/On toggle box next to the control.

Figure 5.36 Use the color picker to select the color tint you want to assign to the slide.

Figure 5.37 After selecting a color, you can see the result of your selection in the Preview panel.

IMAGE ADJUSTMENTS

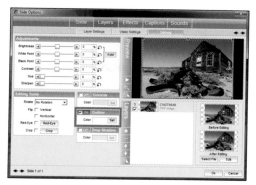

Figure 5.38 Enable the Outline option by selecting the On/Off toggle box next to the control.

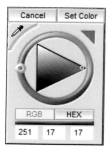

Figure 5.39 Use the color picker to select the color you want to assign to the outline.

Adding Outlines

The Outline control creates a solid color line around the image (**Figure 5.38**). This and the Drop Shadow control are most effective when you're using the image as part of a layer where the effect can be seen more easily.

To use the Outline control, select the On/Off toggle box. By default, the outline will be white. Click the Set button to open the color picker (**Figure 5.39**). Click the outer ring to set the color hue, and click in the triangle to set the color saturation.

Once you've selected the color you want to use, click the Set Color button to apply the change. If you change your mind, you can click the Cancel button to dismiss the color picker without making any changes.

Adding Drop Shadows

The Drop Shadow control creates a solid color line around the image (**Figure 5.40**). This and the Outline control are most effective when the image is used as part of a layer where the effect can be seen more easily.

To use the Drop Shadow control, select the On/Off toggle box to turn the control on. By default, the outline will be white. Click the Set button to open the color picker (**Figure 5.41**). Click the outer ring to set the color hue, and click in the triangle to set the color saturation.

Once you've selected the color you want to use, click the Set Color button to apply the change. If you change your mind, you can click the Cancel button to dismiss the color picker without making any changes.

Figure 5.42 shows both the Outline and Drop Shadow controls in use on a slide. Because these effects appear on the outer edges of a slide, they are most useful when you apply them to a layer that is smaller than the full size of the slide.

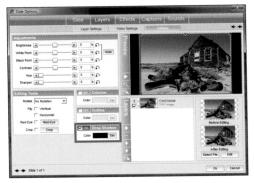

Figure 5.40 Enable the Drop Shadow option by selecting the On/Off toggle box next to the control.

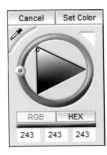

Figure 5.41 Use the color picker to select the color you want to assign to the drop shadow.

Figure 5.42 This is the image after adding an outline and a drop shadow to the image.

IMAGE ADJUSTMENTS

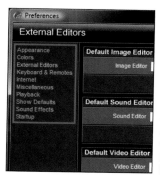

Figure 5.43 Open the Preferences dialog to access the External Editor options in ProShow.

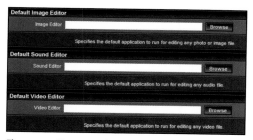

Figure 5.44 You can select external editors for images, audio, and video for those times when you need features that are beyond those included with ProShow.

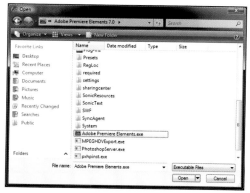

Figure 5.45 Use the standard Windows File > Open dialog to navigate to and select the external editor you want to use with ProShow.

Using External Editors

ProShow can do quite a bit with your images, but sometimes you'll want to do more image editing than what is possible within ProShow. For times like these, you'll use an external editor.

Rather than having to leave the program, open your editing application, and then add the content to ProShow, you can configure the program to open your files directly from within ProShow. This enables you to automatically update your files when you've completed the edits.

To set up external editors, choose Edit > Preferences (**Figure 5.43**). Next, choose External Editors.

ProShow lets you configure default applications for image editing, sound editing, and video editing (**Figure 5.44**).

To select a default editor, you can either type in the path or use the Browse buttons to navigate to the application on your computer (**Figure 5.45**). Select the applications you

continues on next page

want to use, and click OK to save your preferences (**Figure 5.46**).

To work on your image, video, or audio in the editor you've defined, right-click the slide in the Slide list, and choose Customize Slide > Open in Editor (**Figure 5.47**). The file will open for editing in the selected application.

✔ Tip

- If you haven't set a default editor, then the first time you choose Open in Editor, ProShow will prompt you to select a default—essentially, a shortcut to the Preferences dialog.

Figure 5.46 Once you've selected the external editors for ProShow, these programs will be launched with the selected file when you choose the Open Editor command.

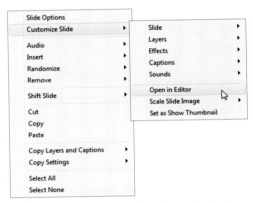

Figure 5.47 Right-clicking a show element—whether it is an image, a video, or an audio file—and choosing Open in Editor will launch the file in the selected editor.

Figure 5.48 You can find the Blur control in the Adjustments controls of the Slide Options dialog's Layers Editing tab.

Figure 5.49 Increasing the Blur amount will add a soft-focus effect to your image.

Figure 5.50 To apply the blur as an adjustment effect, select the Effects tab, and then select the Adjustment Effects tab.

ProShow Producer Adjustments

ProShow Producer adds a number of more advanced editing effects to give you even more control over how your images are presented to the viewer. Along with blurring and vignetting, there are very powerful chroma key and adjustment layer effects that can raise your show quality to an entirely new level of sophistication.

Blur

The Blur control does exactly what you might imagine—it softens the focus on your image, from subtle to complete (**Figure 5.48**).

To add blur to your image, drag the selection handle to the right. Alternatively, you can use the arrows to adjust the effect by 1 percent, or you can enter a value directly into the Blur field (**Figure 5.49**).

One effective use of the Blur control is to create an adjustment effect with the slide going from blurred to in-focus. To do this, select the Effects tab, and then select the Adjustment Effects tab that appears (**Figure 5.50**).

continues on next page

PROSHOW PRODUCER ADJUSTMENTS

In the Starting Position adjustments panel, increase the Blur control to the desired amount (50 percent in the example shown in **Figure 5.51**). Leave the Blur control in the Ending Position adjustments panel at 0 percent. When the slide is played, it will begin with a blur and fade into sharp focus during the duration of the slide.

You can find an example of this and other adjustment effects on the companion Web site at www.proshowbook.com in Chapter 5.

✔ Tip

- I use the selection handle to get the effect roughly where I want it and then fine-tune the adjustment with the arrow keys.

Vignette

The Vignette control is a powerful way to add a soft edge to your image layers (**Figure 5.52**). To use the Vignette control, click the Vignette button in the Editing Tools panel.

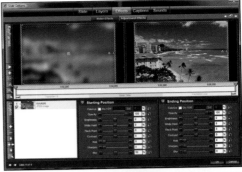

Figure 5.51 Use the Starting Positions and Ending Positions settings to control how the effect is used during the playback of the slide. Here, I'm going from blurred to focused.

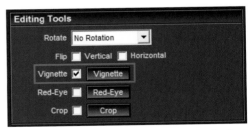

Figure 5.52 Use the Vignette control to add soft edge effects to layers on your slides.

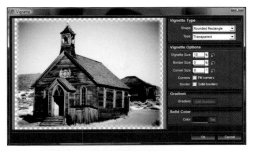

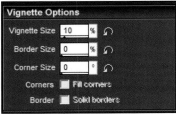

Figure 5.53 The Vignette dialog offers a number of ways to create soft masking effects for images.

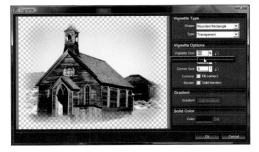

Figure 5.54 By adjusting the size of the shape, you can mask more or less of the image. This mask is covering 43 percent of the layer.

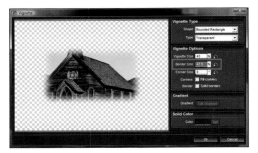

Figure 5.55 Using a larger Border size setting results in a smaller visible area with a larger vignette border applied.

With the Vignette control, you can create a rectangular or elliptical mask with varying degrees of soft blending (**Figure 5.53**). This is a useful way to view multiple layers on your slide without the hard edge of a normal image layer.

For the first example, I've set Shape to Rounded Rectangle and set Type to Transparent. By adjusting the size to 43 percent, I've masked off more of the image (**Figure 5.54**).

The Border Size control adjusts the size of the shape, with smaller numbers creating a rectangle or ellipse and with larger numbers making the shape smaller (**Figure 5.55**).

continues on next page

PROSHOW PRODUCER ADJUSTMENTS

The different types will give your vignette a completely different look. In **Figure 5.56**, an ellipse shape with a Transparent setting masks out everything outside the ellipse.

A Rounded Rectangle shape with a Gradient setting works well when you want to blend the vignette with a range of colors or tones (**Figure 5.57**).

Finally, a Rounded Rectangle shape with a Solid Color setting lets you create a vignette that has more of a cutout appearance by overlaying a solid color on the layer outside the shape area (**Figure 5.58**).

Figure 5.56 An ellipse with transparent border is perhaps the most common vignette type.

Figure 5.57 Using a rounded rectangle with a gradient border offers a completely different feel to the vignette.

Figure 5.58 Using a rounded rectangle with a solid color gives the image more of a cutout look.

Figure 5.59 A slide with each of the different vignette styles applied to different layers. The softer edges help the layers blend together onto the background.

Figure 5.60 Applying a vignette with a transparent edge helps this color layer blend in with the black and white background image.

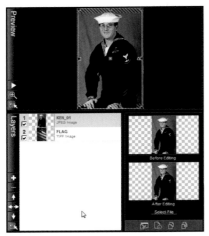

Figure 5.61 For this example, I'll be dropping a flag background into a portrait.

In **Figure 5.59**, I've created a slide that has different vignettes applied to each layer to show an example of how they can be used and combined to give your slides a more polished look and feel.

For another example of how vignetting can help you blend multiple layers together, **Figure 5.60** shows a color image that has been placed on a black and white layer. The color image has a rounded rectangle vignette applied with a transparent edge.

Chroma Key Transparency

If you've seen the weather reports on the nightly news anytime over the past 20 years or so, you already know what a *chroma key* is—a specific color, usually green or blue—masked out to allow other colors to show through. In the weather report, a green screen is replaced with the weather map and other graphics.

ProShow Producer includes a chroma key transparency feature that works much the same way. By masking out a specific color in one layer, you can see what's beneath it on the other layer, making complex blending a possibility for your shows.

To create a chroma key transparency, create a slide with multiple layers. In this example, I've placed a portrait on one layer with a flag background on a second layer (**Figure 5.61**).

Begin by selecting the On/Off toggle box for Chroma Key Transparency. Now, click the Set Color button to set the chroma key color, and

continues on next page

click the color you want to mask out of the first layer (**Figure 5.62**).

Click the eyedropper to select it, and then click the color in your image that will be used as the key color, which will be masked out (**Figure 5.63**).

As you can see in the previous figure, not much of the blue background is being masked out yet. That's because all the adjustments are set to 0, which means only the exact pixel values clicked will be masked out. To widen the selection, you can use the Hue controls:

◆ **Hue Threshold** controls the range of color values that will be selected. Higher numbers will give you a wider range of the color—in this example, blue—that will be selected.

◆ **Hue Drop Off** defines how much color is kept at the edges of the threshold. Lower numbers will keep more of the edge colors, while higher numbers will keep less.

◆ **Intensity Threshold** affects the darkest and lightest areas of the image; with lower numbers, the areas become more transparent.

◆ **Intensity Drop Off**, like Hue Drop Off, controls the edges of the areas included in the Intensity Threshold adjustment.

◆ **Color Suppression** is the last control and removes the key color from the edge of the image. Higher numbers here will give that range of color a washed-out look.

In **Figure 5.64**, I've used settings of 9 for Hue Threshold, 40 for Hue Drop Off, 17 for Intensity Threshold, and 10 for Intensity Drop Off, with no adjustment to Color Suppression. This allows the blue background to be masked out of the image, with the underlying flag layer showing through.

Figure 5.62 Click the Set Color button to open the color picker, and click the eyedropper to select a color from your image to use as the key color.

Figure 5.63 Clicking your image and then choosing Set Color in the color picker will lock that color in as the key color to be masked out.

Figure 5.64 With the values I've used in the Chroma Key Transparency adjustments, my flag layer is now showing through in areas that contain the blue background of the top layer.

PROSHOW PRODUCER ADJUSTMENTS

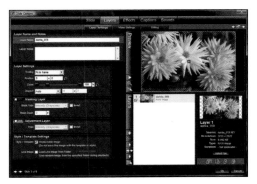

Figure 5.65 To create an adjustment layer, begin by opening the Layers tab in the Slide Options dialog, and then select the Layer Settings tab.

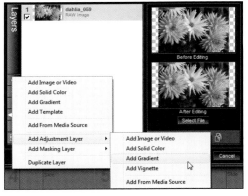

Figure 5.66 To add an adjustment layer to your slide, click the Add button, and choose Add Adjustment Layer > Add Gradient.

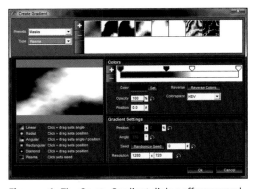

Figure 5.67 The Create Gradient dialog offers several sets of gradient types, and you can also create your own. For this example, we're using one of the Plasma gradients.

Adjustment Layers

Adjustment layers apply all changes made to the adjustment layer to all layers below it. As an example, if an adjustment layer is created with a contrast adjustment, all layers below the adjustment layer will have their contrast adjusted to match.

To create an adjustment layer, begin by double-clicking the slide you want to work on, or click the Slide button in the toolbar. In the Slide Options dialog that opens, select the Layers tab, and then select the Layer Settings tab (**Figure 5.65**).

Gradient Adjustment Layers

I'll show how to create a simple gradient adjustment layer for this first example.

Click the Add button, and choose Add Adjustment Layer > Add Gradient (**Figure 5.66**).

This will open the Create Gradient dialog. There are several preset types, but for this example, we'll keep the Masks preset. From the Type drop-down menu, choose Plasma, and in the list of thumbnails, choose the fourth thumbnail (**Figure 5.67**).

continues on next page

Click the OK button to accept this masking option. The Layers list is now updated with an additional layer titled Gradient 1 and the Adjust badge, which is a small label that lets you know what type of layer it is. You can also see that this adjustment layer has been overlaid on your image (**Figure 5.68**).

Because you created this as an adjustment layer, the Adjustment Layer check box has already been selected. By default, Type will be set to Intensity (Grayscale), which is what you want for this exercise. Next, click the Editing tab (**Figure 5.69**). To make the effect a bit more dramatic, increase the White Point slider to 15, and decrease the Black Point slider to -19 (**Figure 5.70**).

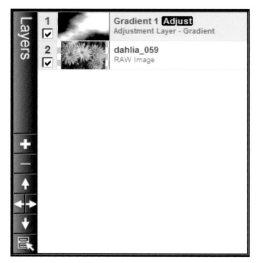

Figure 5.68 After you add an adjustment layer, the Layers list is updated. The new layer has a label to indicate that it isn't a normal layer.

Figure 5.69 In the Adjustments panel of the Editing tab, you can modify the White Point and Black Point controls to enhance the effect.

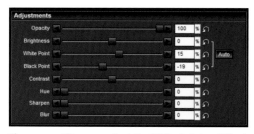

Figure 5.70 After you adjust the White Point and Black Point controls, the effect becomes more obvious.

ProShow Producer Adjustments

Figure 5.71 Prior to the application of the adjustment layer, the image has even lighting throughout with no real focal point.

Figure 5.72 Once I apply the adjustment layer, there is more contrast in the image, and the center of the frame is brighter, giving the eye a natural focal point.

Click OK to apply the adjustment layer to your slide. When you view the slide, you'll now see that the areas of white in the adjustment layer are causing the image to appear brighter, while the black areas are darkening the image. The gray shades are allowing different levels of the lightening and darkening to be seen. For a comparison, **Figure 5.71** shows the slide with no adjustment layer, while **Figure 5.72** shows the same slide with the adjustment layer I just created.

Vignette Adjustment Layers

To create a vignette adjustment layer, begin by clicking the Add button and choosing Add Adjustment Layer > Add Vignette (**Figure 5.73**).

This will create a new adjustment layer on your slide and automatically open the Vignette dialog you saw earlier in this chapter.

continues on next page

Figure 5.73 Choose Add Vignette from the Add Adjustment Layer menu.

For this example, I'm going to create an ellipse shape with a solid color type. The default color is black, but I'd rather use a color that goes with the slide. Clicking the Set Color button in the Solid Color dialog, I open the color picker and select the eye-dropper (**Figure 5.74**).

I've selected a color near the upper-right corner of the image, ensuring that the vignette now has a matching color to use as the fill. Click Set Color to apply the change (**Figure 5.75**).

To make the vignette a more gradual shape, increase the Vignette Size control. In **Figure 5.76**, I've used a setting of 30.

Click OK to apply the changes and view the finished result (**Figure 5.77**).

Figure 5.74 Use the color picker to select a color to use for the vignette.

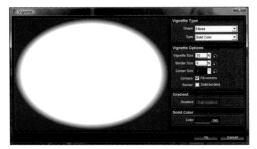

Figure 5.75 Use the eyedropper to select the color to be used for the vignette, and then click Set Color to apply the change.

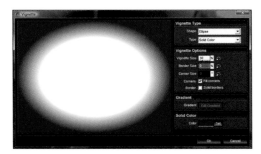

Figure 5.76 After the Vignette Size is adjusted to 30, the shape has a softer and more gradual edge.

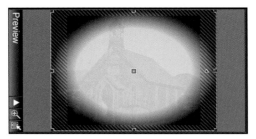

Figure 5.77 After I apply the vignette adjustment layer, all layers below this will include the vignette effect.

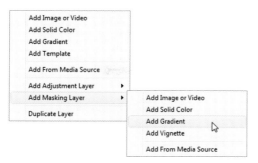

Figure 5.78 Choose Add Masking Layer > Add Gradient to create a gradient fill masking layer.

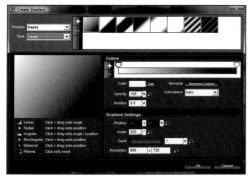

Figure 5.79 Select one of the Linear gradients for the mask.

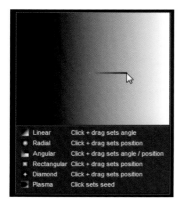

Figure 5.80 Change the angle of the gradient by clicking and dragging to set the direction.

Masking Layers in Producer

A *mask* is a type of layer that is used to block out areas of a layer below it. You can use masking layers to hide parts of a photo, create borders, and blend images.

To create a masking layer, open the Slide Options dialog by clicking the Slide button or double-clicking the selected slide. With the Layers/Editing tab selected, click the Add button, and choose Add Masking Layer > Add Gradient (**Figure 5.78**).

In the Create Gradient dialog, choose Linear for the Type setting. In this example, you can use the first preset, Masks (**Figure 5.79**).

Next, you can change the angle and sharpness of the gradient. Begin by clicking the gradient and dragging the mouse to the right. This will change the angle so that black is on the left and white is on the right (**Figure 5.80**).

continues on next page

For this mask, if you want to have a sharper cutoff between black and white, you can use the color settings to add a point to the color ramp. To do this, click the pointer at the black end of the scale, and drag a new point about halfway across the ramp (**Figure 5.81**). You can see that the gradient is much sharper from black to a gradual white now.

To make the change in white more abrupt, add another point to the color ramp, dragging the white pointer toward the middle (**Figure 5.82**). Keep some space between the two center points if you want to have a smoother transition between the dark and light sides of the mask.

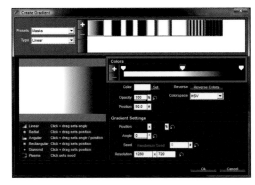

Figure 5.81 To mask out more of the image, add a control point on the black side of the color ramp.

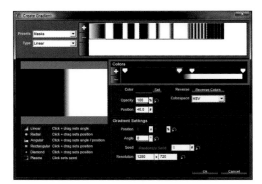

Figure 5.82 Adding another point to the color ramp, this time on the white side, narrows the transition area of the mask.

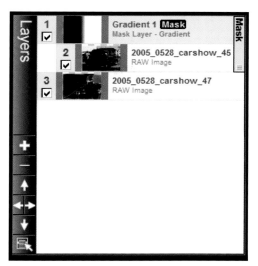

Figure 5.83 The Layers panel shows the masking layer that has been applied to the first layer of the slide.

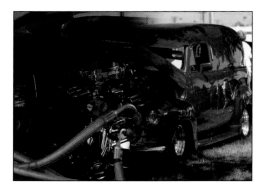

Figure 5.84 The finished shot with the mask as it will appear during the playback of the show.

Click OK to apply the mask to the layer. The preview will show the layer mask as it's applied to the slide. Where the mask is black, the masked layer is hidden, allowing anything below it to show through. Where the mask is white, the layer shows, and the underlying layers are hidden from view (**Figure 5.83**).

Click OK to save your changes. The Preview panel shows the masked slide as it will look during the show (**Figure 5.84**).

✔ Tip

- An easy way to remember how grayscale masks work is that "black conceals and white reveals."

MENUS AND MORE

Menus are your viewers' first opportunity to interact with your shows. With ProShow, you can add fully customized menus to your shows in many of the different output formats. Depending on the complexity of your shows, you can build multiple-page menus, add background music, and create links to URLs. Some of these features are limited to ProShow Producer, but both ProShow Gold and ProShow Producer let you create a menu that invites your viewers to watch your shows.

With the Customize options, you can use existing themes or layouts, or you can modify them to suit your needs. If you're using ProShow Producer, you can even create your own themes.

Adding and Customizing Menus

To access the menu options, you first need to save your show. Click the Save button, or choose File > Save (**Figure 6.1**).

In the Save dialog, click Create Output. Choose one of the formats that supports menus. These are the available options:

◆ DVD

◆ Blu-ray

◆ Share Show

◆ Flash

◆ Web Show

◆ PC Executable

◆ Tutorun CD

◆ Video CD

◆ E-Mail

For this example, I'll use the Create DVD option. In the Create DVD dialog, select the Menu tab (**Figure 6.2**).

Selecting a Theme

ProShow includes several *themes*, or ready-made layouts, that you can use. These themes give your show a professional look with little or no effort on your part. To use one of the themes, select it from the scrolling list on the right side of the dialog (**Figure 6.3**).

If you have a large number of themes, you can narrow the list down by using one of the filters in the drop-down menu above the theme thumbnails.

Click the drop-down menu to view the available theme categories (**Figure 6.4**).

Figure 6.1 Click Save or choose File > Save to save your show before creating a menu.

Figure 6.2 The Menu tab of the Create DVD dialog is where you'll find all the basic menu tools in ProShow.

Figure 6.3 The theme list on the right side of the Menu dialog lets you pick from any installed theme to quickly give your show a polished look.

Figure 6.4 You can narrow the list of choices by choosing the category from the drop-down theme menu.

Figure 6.5 After I select a theme, the new background is in place for my menu. For this show, I've selected a template that looks a little like rust and dirt, appropriate for a ghost town.

Figure 6.6 The plus (+) button above the Themes drop-down menu will connect you to the Photodex site, where additional content is available for both Gold and Producer.

Figure 6.7 The Download Content dialog offers a number of categories to choose from. Click one or more options to download and install the additional content in ProShow.

Select one of the templates from the thumbnail list to use as the basis for your menu screens (**Figure 6.5**).

The theme you select not only sets the background image; it also applies colors and styles to the fonts used on the menu.

You can add more themes to your shows by clicking the plus button (**Figure 6.6**). This will open the Download Content dialog, which will connect to the Photodex Web site so you can download extras (**Figure 6.7**).

continues on next page

Any extras that you have already installed will appear as such if you return to the Download Content dialog, so you don't need to worry about installing items multiple times (**Figure 6.8**).

After you install additional content, the new themes will appear in the thumbnails list, and any new categories will be added to the Themes drop-down menu (**Figure 6.9**).

Changing Menu Contents and Layout in ProShow Gold

One of the first steps you'll want to take is to change the title of your show. To do this, select the text in the Title field (**Figure 6.10**).

Enter a new name for your menu. In this example, I'm using "Bodie – Boomtown of Old" (**Figure 6.11**).

If your menu thumbnail uses a video clip, selecting the "Use video thumbnails that loop after" check box will force your videos to run in a constant loop, showing for the number of seconds (five seconds by default) that you choose.

✔ Tip

- For an example show that uses looping video on the menu, please visit the book's companion Web site at *www. proshowbook.com/chapter6.*

Figure 6.8 If you return to the Download Extras dialog, any previously downloaded content will be noted as installed.

Figure 6.9 The Themes drop-down menu will update with the new categories you have downloaded from the Download Extras option.

Figure 6.10 To change the main text from the default of Photodex ProShow, select and replace the text in the Title field.

Figure 6.11 After I replace the default text, the new menu shows a more appropriate title.

Figure 6.12 Use the Menu Layout controls to access layout presets or create your own layout.

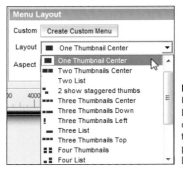

Figure 6.13 Use the Layout drop-down menu to access the preset menu layouts.

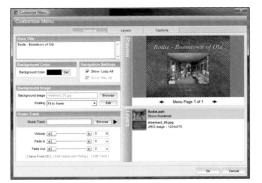

Figure 6.14 The Customize Menu dialog is where you create and customize all new menus.

Figure 6.15 You can use the color picker to set a background color if you aren't using a theme for your menu.

To change the layout of items on your menu page, use the Menu Layout controls (**Figure 6.12**). These allow you to select from predesigned layouts or custom layouts that you create and can save for future use.

To select a new menu layout, click the Layout drop-down menu to view the available layouts (**Figure 6.13**). Each is represented by a thumbnail to give you an example of what the layout looks like prior to selecting it.

If none of the existing presets is what you have in mind for your menu, click the Create Custom Menu button to open the Customize Menu dialog (**Figure 6.14**).

The Customize Menu dialog has three tabs—General, where you can set titles, background colors and images, navigation settings, and music; Layers, where you get control over layer adjustments; and Captions, where you set all the text options.

To change the main title:

◆ Select the existing text in the Main Title field, and type the replacement text. I've already set the title in the Create DVD dialog's Title field, so I don't need to reset it here. The Title field in the Create dialog and the Main Title field in the Customize Menu dialog are identical and linked to each other, so changes made to one will be reflected in the other.

If you're not using a theme for your menu, you can change the background color to anything you like. To set the background color of your menu, click the Background Color Set button to open a color picker (**Figure 6.15**).

continues on next page

To use a background image, click the Browse button in the Background Image control (**Figure 6.16**).

You'll see two options: Add Image File and Add From Media Source (**Figure 6.17**).

Choosing Add Image File opens a standard File Open dialog. Navigate to the file you want to use, and click Open to select it. If needed, choose a Scaling option from the drop-down menu. In **Figure 6.18**, I've replaced the background image with my own and used the "Fill frame" Scaling option.

To select from a media source, an add-on package available from Photodex, choose Add From Media Source, which will open the Select MediaSource dialog (**Figure 6.19**).

Figure 6.16 To use your own background image in a menu, click the Browse button.

Figure 6.17 Select from an image file or from a media source if you have one of these add-on options installed.

Figure 6.18 The menu after replacing the background with my own image.

Figure 6.19 The Select MediaSource dialog will let you select from any installed MediaSource content. MediaSources are add-on packages of content—templates, borders, masks, menus, and music—that you can buy for ProShow use.

ADDING AND CUSTOMIZING MENUS

Figure 6.20 Click the Browse button to add music to your menu.

Figure 6.21 You must agree to the copyright explanation before importing music from a CD.

Figure 6.22 Import one or more audio tracks from a CD with the Save Audio Track dialog.

To add music to your menu:

◆ Click the Browse button in the Music Track options (**Figure 6.20**). As with the background options, you can select either from a file on your computer or from an installed MediaSource.

Or

1. To copy music directly from a CD, click the Save from CD link below the slider controls. You'll see a copyright explanation about using copyrighted music in a show (**Figure 6.21**).

2. After clicking OK, you will be prompted to import the music.

3. With the Save Audio Track dialog open, select the track or tracks you want to import (**Figure 6.22**).

continues on next page

ADDING AND CUSTOMIZING MENUS

By default, ProShow doesn't know the name of the album or artist, just the list of tracks and playtimes. When you select the Track Info check box, ProShow will retrieve the information about the CD from the Internet and display the details in the Available Audio Tracks list (**Figure 6.23**).

4. Select the track you want to import. Although multiple tracks can be selected, only one track at a time will be imported (**Figure 6.24**).

 Two types of audio are supported by ProShow—OGG, which is a Vorbis audio format, and MP3, which is an MPEG audio format. MP3 is a more common format and widely available, but OGG is a higher-quality format. Unless you'll also be using this audio outside of ProShow, I recommend using the OGG format.

5. Clicking the Save Track button will open the Save CD Audio Track dialog (**Figure 6.25**). Choose the location where you want to save the file.

Figure 6.23 Selecting the Track Info check box will retrieve the information from the Internet, making it a bit easier to see which track you are selecting.

Figure 6.24 Select the track you want to import for your menu audio.

Figure 6.25 Save the file to the location you select.

Figure 6.26 After you add audio to your menu, the other editing options will be enabled.

Figure 6.27 The Edit Fades and Timing dialog gives you much finer control over the fades in your audio track.

Figure 6.28 Use the Zoom control to expand the audio track until you can see seconds listed in the track timeline.

Once you add the audio file to your show, the Volume, Fade In, and Fade Out sliders will be enabled. You will also be able to access the Edit Fades and Timing and Edit Track options (**Figure 6.26**).

Volume controls the overall level of the audio playback. The default value is 100 percent; the range is 0 percent, or silent, to 200 percent.

Fade In and Fade Out control how the volume changes at the beginning and end of playback. Adding a Fade In of five seconds will raise the volume from silent to the level set in the Volume control over a five-second period.

Edit Fades and Timing opens the Edit Fades and Timing dialog (**Figure 6.27**). This dialog gives you much more control over the fades in your music.

By default, the track display shows the full length of the audio track. Using the Zoom control to take a closer look at the timing will allow for better placement for your Fade In and Fade Out settings. Slide the Zoom slider to the right until you have a track display in seconds (**Figure 6.28**).

continues on next page

In the lower-left and lower-right corners of the timeline, a shaded box indicates where the fade effect will occur. To make an adjustment, you can drag the box to the point you want the fade to end (for fade in) or begin (for fade out). The track timeline will be updated with a graduated background, and the Fade In or Fade Out field will update with the timing (**Figure 6.29**).

The Edit Track link on the Music Track controls will open your default external sound editor (set in the Preferences dialog) (**Figure 6.30**). For more information on selecting external editors, see Chapter 2.

Applying Layers Settings

The Layers tab allows you to control the appearance of your layers (**Figure 6.31**).

For each layer on the menu, you can control the size of the image, as well as make adjustments to its appearance. The adjustment options are the same as those covered in the "Image Adjustments" section of Chapter 5.

To change the size of any layer on the menu:

◆ Use the Zoom control in the Layer Settings panel (**Figure 6.32**), or drag a

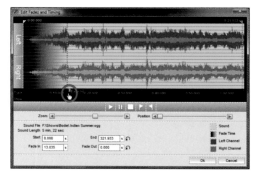

Figure 6.29 The track timeline will indicate where the fade effect is placed when you drag the Fade slider or enter a value in the Fade In or Fade Out field.

Figure 6.30 You can do more advanced editing of your soundtracks in an external editor.

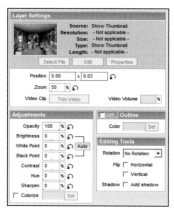

Figure 6.31 Use the Layers tab to configure your layer settings, such as image sizes and positions.

Figure 6.32 You can change the size of an image by entering a value in the Zoom field.

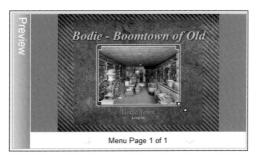

Figure 6.33 As an alternative to the Zoom control, drag one of the image handles in the Preview panel to change the image size.

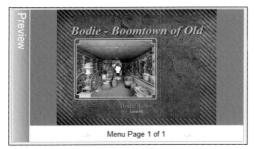

Figure 6.34 Move the image to the new location by dragging the thumbnail to the desired location.

Figure 6.35 The Outline and Editing Tools controls let you make adjustments to how the thumbnail is displayed on the menu page.

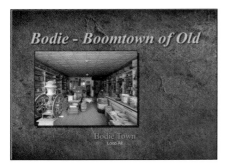

Figure 6.36 Adding a black outline and a shadow makes the show thumbnail stand out from the background.

blue selection handle on the image in the Preview panel to change the size directly (**Figure 6.33**).

Along with sizing the image, you can change its position on the menu by using the Position controls or by dragging the image to the new location in the Preview panel (**Figure 6.34**).

The Outline and Editing Tools controls allow you to make adjustments to the selected layer (**Figure 6.35**). I find that the Outline and Shadow options are an effective way of making your show thumbnails stand out on the menu page (**Figure 6.36**).

Applying Captions Settings

The final tab in the Customize Menu dialog is Captions (**Figure 6.37**). Here you can change what text appears on the menu and select a font, size, and color for each caption.

You can also change the location of the text by dragging it in the Preview panel.

To add a caption to your menu:

◆ Click the + button, and enter the new text in the Caption Text field (**Figure 6.38**). Captions can be broken onto multiple lines by pressing the Return key while typing the caption.

To change the font of the caption:

◆ Choose a new font from the Font drop-down menu. You can also set size and text color and decide whether to use bold or italics.

The Caption Settings controls provide the option to add a drop shadow or an outline to the caption. You can also set the alignment for the caption and use the Position control to place the caption in the desired location. I find it easier to click the caption in the Preview panel and drag it to the location I want (**Figure 6.39**).

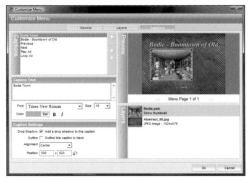

Figure 6.37 The Captions tab contains all the settings that apply to text on your menu page.

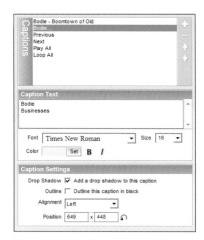

Figure 6.38 Captions are entered in the Caption Text field. To use multiple lines, press Return.

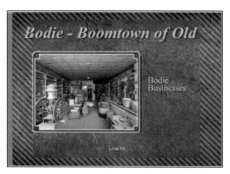

Figure 6.39 Click and drag the caption to the desired location on the menu page.

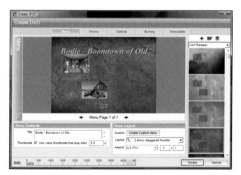

Figure 6.40 Menus containing multiple shows work in the same fashion as single-show menus.

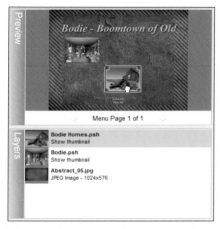

Figure 6.41 To modify the layout of your show thumbnails, use the Customize Menu dialog. By selecting the Layers tab, you can position the thumbnails anywhere on the page.

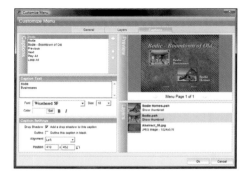

Figure 6.42 Position the captions where desired, and make any adjustments to the Font, Size, and Color options to suit your show.

If your menu has multiple shows, the options for layout are the same as for a single show menu. Start by selecting one of the Menu Layouts controls for a multiple show menu, shown as thumbnails in **Figure 6.40**.

To change the default layout of the show thumbnails:

1. Click Create Custom Menu to open the Customize Menu dialog.

2. Select the Layers tab, and select the layer you want to move (**Figure 6.41**).

3. The thumbnail for the selected layer will be highlighted with selection handles and a blue frame. Drag the thumbnail to change the location of it on the menu page.

4. Once all the thumbnails are positioned on the menu page, select the Captions tab to set the text options.

5. Click the caption you want to position or change, and make the adjustments as outlined earlier (**Figure 6.42**).

 With multiple shows, the "Loop All" and "Play All" captions will be placed on your menu. When the viewer selects either of these options, the shows will play sequentially one or more times.

 continues on next page

The completed menu, shown in **Figure 6.43**, contains the modified layout and custom caption adjustments.

6. If you want to save this menu layout for future use, click the disk icon above the Themes thumbnail list (**Figure 6.44**) to open a File Save dialog. Enter a name for your menu (**Figure 6.45**).

Figure 6.43 The finished menu with all adjustments applied.

Figure 6.44 Click the disk icon to save a custom menu layout for future use.

Figure 6.45 Give the custom menu a meaningful name to help you locate it in the future.

Figure 6.46 To change the main text from the default of Photodex ProShow, select and replace the text in the Title field.

Figure 6.47 After you replace the default text, the new menu shows a more appropriate title.

Figure 6.48 The Menu Layout controls allow you to access layout presets, or you can create your own layout.

Changing Menu Contents and Layout in ProShow Producer

ProShow Producer offers similar options for creating menus to ProShow Gold. With Producer, however, you have the ability to create multipage menus and to set the music, backgrounds, and other features for each menu page separately.

One of the first steps you'll want to take is to change the title of your show. To do this, select the text in the Title field (**Figure 6.46**).

Enter a new name for your menu. In this example, I'm using "USS Nimitz—CVN65" (**Figure 6.47**).

If your menu thumbnail uses a video clip, you can select the "Use video thumbnails that loop after" check box to force your videos to run in a constant loop, showing for the number of seconds (five seconds by default) that you choose.

To change the layout of items on your menu page, the Menu Layout controls (**Figure 6.48**) let you select from predesigned layouts or from custom layouts that you create and can save for future use.

continues on next page

ADDING AND CUSTOMIZING MENUS

To select a new menu layout, click the Layout drop-down menu to view the available layouts (**Figure 6.49**). Each is represented by a thumbnail to give you an example of what the layout looks like before you choose it.

If none of the existing presets is what you have in mind for your menu, click the Create Custom Menu button to open the Customize Menu dialog (**Figure 6.50**).

✔ Tip

- For an example show that uses looping video on the menu, please visit the book's companion Web site at *www.proshowbook.com/chapter6*.

Customizing Menus

The Customize Menu dialog has four tabs—General, where you can set titles, backgrounds, navigation settings, and music for your menu; Thumbnails, which offers options to animate and highlight show thumbnails and add shows to your menus; Layers, where you make layer adjustments; and Captions, where you set all the text options.

To change the main title of your show:

◆ Select the existing text in the Main Title field, and type the replacement text. I've already set the title in the Create DVD dialog Title field (shown earlier in Figure 6.47), so I don't need to set it here. The Title field in the Create DVD dialog and the Main Title field in the Customize Menu dialog are identical, so changes made to one will be reflected in the other.

If you're not using a theme for your menu, you can change the background color to anything you like. To set the background color of your menu, click the Background Color Set button to open a color picker (**Figure 6.51**).

Figure 6.49 Use the Layout drop-down menu to access the preset menu layouts.

Figure 6.50 The Customize Menu dialog is where you can customize all new and existing menus.

Figure 6.51 You can use the color picker to set a background color if you aren't using a theme for your menu.

Figure 6.52 To use your own background image in a menu, click the Browse button.

Figure 6.53 Select from an image file or from a MediaSource if you have one of these add-on options installed.

Figure 6.54 In the Select MediaSource dialog you can select from any installed MediaSource content.

Figure 6.55 Click the Browse button to add music to your menu.

If your show has multiple pages, you can set a different background color for each page by selecting the page thumbnail and choosing "Custom color for this page."

To use a background image, click the Browse button in the Background Image section (**Figure 6.52**).

You'll be able to select the Add Image File or Add From Media Source option (**Figure 6.53**).

Choosing Add Image File opens a standard File Open dialog. Navigate to the file you want to use, and click Open to select it. If needed, choose a Scaling option from the drop-down menu.

To select to use MediaSource content, which are add-on packages available from Photodex, select Add From Media Source, which will open the Select MediaSource dialog (**Figure 6.54**).

If your menu has multiple pages, you can set a different background image for each page by selecting the page thumbnail and selecting "Custom image for this page."

To edit the background image, click the Edit button after choosing a background image. The image will open in the default external image-editing program you configured in Preferences. Refer to Chapter 2 for information on selecting default editors.

To add music to your menu:

◆ Click the Browse button in the Music Track options (**Figure 6.55**). As with the background options, you can select either from a file on your computer or from an installed MediaSource.

continues on next page

ADDING AND CUSTOMIZING MENUS

Or

1. To copy music directly from a CD, click the Save From CD link below the slider controls. You'll see a copyright explanation about using copyrighted music in a show (**Figure 6.56**).

2. After clicking OK, you will be prompted to import the music.

3. With the Save Audio Track dialog open, select the track or tracks you want to import (**Figure 6.57**).

By default, ProShow doesn't know the album or artist name, just the list of tracks and playtimes. When you select the Track Info check box, ProShow will retrieve the information about the CD from the Internet and display the details in the Available Audio Tracks list (**Figure 6.58**).

Figure 6.56 You must agree to the copyright explanation before importing music from a CD.

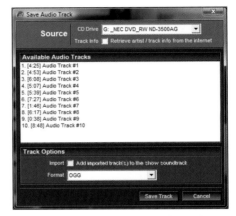

Figure 6.57 Import one or more audio tracks from a CD with the Save Audio Track dialog.

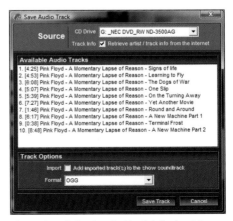

Figure 6.58 Selecting the Track Info check box will retrieve the information from the Internet, making it a bit easier to locate the track you want.

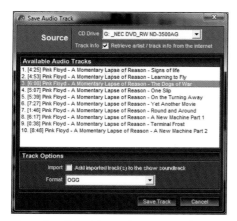

Figure 6.59 Select the track you want to import for your menu audio.

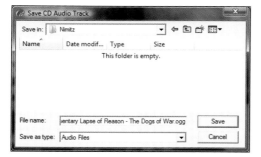

Figure 6.60 Save the file to the location you select.

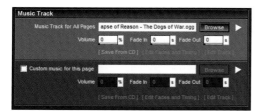

Figure 6.61 After adding audio to your menu, the other editing options will be enabled.

Figure 6.62 The Navigation Settings options control whether "Loop All" and "Play All" display on your menus.

4. Select the track you want to import. Although you can select multiple tracks, only one track will be imported or accessed at any time (**Figure 6.59**).

ProShow supports two types of audio—OGG, which is a Vorbis audio format, and MP3, which is an MPEG audio format. MP3 is a more common format and widely available, but OGG is a higher-quality format. Unless you'll also be using this audio outside of ProShow, I recommend using the OGG format.

5. Clicking the Save Track button will open the Save CD Audio Track dialog (**Figure 6.60**). Choose the location where you want to save the file.

Once you've added the audio file to your show, the Volume, Fade In, and Fade Out sliders will become enabled. You will also be able to access the Edit Fades and Timing and Edit Track options (**Figure 6.61**).

Volume controls the overall level of the audio playback. The default value is 100 percent; the range is 0 percent, or silent, to 200 percent.

Fade In and Fade Out control how the volume changes at the beginning and end of playback. Adding a fade-in of five seconds will raise the volume from silent to the level set in the Volume control over a five-second period.

The Navigation Settings options determine whether the "Loop All" and "Play All" captions appear on your menus (**Figure 6.62**). Play All will be available only if the menu includes multiple shows.

Working with Thumbnails

The Thumbnails tab is where you add shows to your menu and control how viewers interact with thumbnails (**Figure 6.63**).

To add another show to your menu, click the + button in the Shows controls (**Figure 6.64**).

If your menu layout has only one thumbnail, ProShow Producer will automatically add another menu page to hold the new show, with the same settings as the existing page (**Figure 6.65**).

Figure 6.63 Use the Thumbnails tab to add shows to a menu and to control how thumbnails appear onscreen.

Figure 6.64 To add a show to the menu, click the + button.

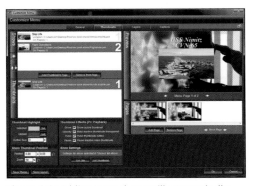

Figure 6.65 Adding more shows will automatically create menu pages if needed. Each menu page will have the same layout settings as the original page.

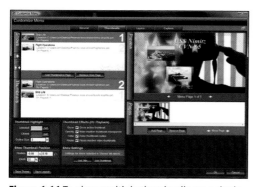

Figure 6.66 To place multiple thumbnails on a single menu page, select a multiple thumbnail menu layout.

Figure 6.67 The Thumbnail Highlight controls let you set a color outline to appear around the thumbnail when it's selected.

Figure 6.68 Select the colors to use for the thumbnail highlights by clicking the Set button and choosing the color with the color picker.

Figure 6.69 The Show Thumbnail Position controls allow you to change the location and size of a thumbnail on the menu page.

Figure 6.70 Alternatively, you can move the thumbnail to the desired location by dragging it in the Preview panel.

Changing to a menu layout with multiple thumbnails will move the additional thumbnails to the main menu page (**Figure 6.66**).

◆ Use the Thumbnail Highlight controls to set the outline to appear around a selected thumbnail when the viewer clicks that show (**Figure 6.67**).

◆ To change the color of either highlight, click the Set button to open a color picker (**Figure 6.68**). To change the width of the outline, enter a new value in the Outline Size field, or drag the slider to the desired size.

◆ To change the position of a thumbnail on the menu page, you can use the Show Thumbnail Position controls (**Figure 6.69**) or move the thumbnail in the Preview panel by dragging the thumbnail to where you want it (**Figure 6.70**).

continues on next page

The Thumbnail Effects controls function only when a menu is displayed on a computer (it's not available for shows played on TV or on Web sites). With these controls, you can animate the thumbnails to grow, change opacity, pulse (to show highlight or selection), and pause a video (**Figure 6.71**).

Figure 6.71 Use the Thumbnail Effects options for shows that will play on a computer.

Applying Layers Settings

The Layers tab lets you control the appearance of the layers in your menu (**Figure 6.72**).

For each layer on the menu, you can control the size of the image, as well as make various adjustments. The adjustment options are the same as those covered in the "Image Adjustments" section of Chapter 5.

To change the size of any layer on the menu:

◆ Use the Zoom control in the Layer Settings panel (**Figure 6.73**), or drag the blue selection handle on the image in the Preview panel to change the size directly (**Figure 6.74**).

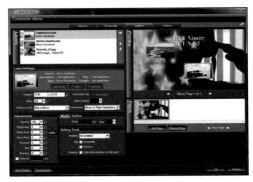

Figure 6.72 Use the Layers tab to configure your layer settings, such as image size and position.

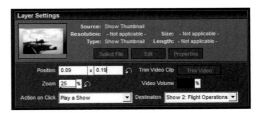

Figure 6.73 You can change the size of an image by entering a value in the Zoom field.

Figure 6.74 As an alternative to the Zoom control, drag one of the image handles in the Preview panel to change the image size.

ADDING AND CUSTOMIZING MENUS

Figure 6.75 Move the image to the new location by clicking the thumbnail and dragging to the desired location.

Figure 6.76 The Action on Click drop-down menu lets you add interactive features to your menus.

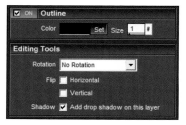

Figure 6.77 The Outline and Editing Tools controls let you make adjustments to how the thumbnail is displayed on the menu page.

Figure 6.78 Adding a black outline and a shadow helps the show thumbnail stand out from the background.

Along with sizing the image, you can change the position on the menu by using the Position controls or by dragging the image to the new location in the Preview panel (**Figure 6.75**).

To set the action for a thumbnail selection:

◆ Choose the action from the Action on Click drop-down menu (**Figure 6.76**). Typically, you'd play a show when clicking the thumbnail, but Producer gives you more control by letting you add layers that allow your viewers to interact with the show. You'll learn more about this later in the "Making Your Shows Interactive" section of this chapter.

When Play a Show is selected in the Action on Click drop-down menu, you can choose which of the shows in your project that will play.

The Outline and Editing Tools controls allow you to make adjustments to the selected layer (**Figure 6.77**). I find that the Outline and Shadow options are an effective way of making your show thumbnails stand out on the menu page (**Figure 6.78**).

To select an outline color:

◆ Click the Set button to open a color picker. You can modify the width of the outline by using the Size field.

Applying Caption Settings

The final tab in the Customize Menu dialog is the Captions tab (**Figure 6.79**). Here you can change what text is shown on the menu and select a font, size, and color for each caption.

You can also change the location of the text by dragging it in the Preview panel.

To add a caption to your menu:

◆ Click the + button at the left of the Captions panel, and enter the new text in the Caption Text field (**Figure 6.80**). You can set captions to appear on multiple lines by pressing the Return key while typing the caption.

To change the font of the caption:

◆ Choose a new font from the Font drop-down menu. You can also set size, text color, and whether to use bold or italics.

The Caption Settings controls provide the option to add a drop shadow or an outline to the caption. You can also select the alignment for the caption and use the Position control to place the caption on the menu in the desired location. I find it easier to click the caption in the Preview panel and drag it to the location I want (**Figure 6.81**).

By choosing an option in the Action on Click drop-down menu, you can control what happens when a viewer clicks a caption (**Figure 6.82**). You'll learn more about interactivity later in this chapter.

With ProShow Producer, you can also change the opacity of the text in your captions. Enter a value in the Opacity field, or drag the slider to achieve the effect you want (**Figure 6.83**).

Figure 6.79 The Captions tab contains all the settings that apply to text on your menu page.

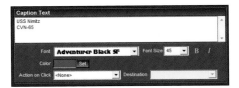

Figure 6.80 To add a caption to your menu, click the + button in the Captions panel.

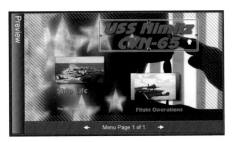

Figure 6.81 Click and drag the caption to the desired location on the menu page.

Figure 6.82 The Action on Click settings allow you to add interactivity to your captions.

Figure 6.83 You can set the opacity for a caption with the Caption Settings controls.

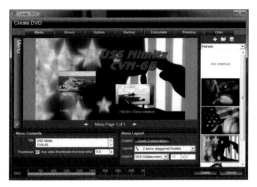

Figure 6.84 Menus with multiple shows work in the same fashion as single-show menus, with the option to lay out the thumbnails and captions in a way that works best for you.

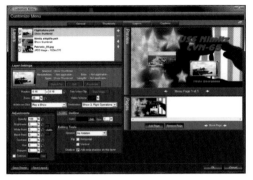

Figure 6.85 Change the layout of your menu thumbnails from the Layers tab of the Customize Menu dialog.

Figure 6.86 Position the captions where desired, and make any adjustments to the Font, Size, and Color options to suit your show.

Using Multishow Menus

If your menu has multiple shows, the options for layout are the same as for a single-show menu. Start by selecting one of the menu layouts for a multiple-show menu, such as the "2 show staggered thumbs" layout shown in **Figure 6.84**.

To change the default layout of the show:

1. Click Create Custom Menu to open the Customize Menu dialog.

2. Click the Layers tab, and select the layer you want to move (**Figure 6.85**).

3. The thumbnail for the selected layer will be highlighted with selection handles and a blue frame in the Pages panel of the dialog. Click and drag to change the location of the thumbnail on the menu page.

4. Once all the thumbnails are positioned on the menu page, select the Captions tab to set the text options.

5. Click the caption you want to position or change, and make the adjustments as outlined earlier (**Figure 6.86**).

With multiple shows, the "Loop All" and "Play All" captions will be placed on your menu. When the viewer selects either of these options, the shows will play sequentially one or more times.

continues on next page

The completed menu, shown in **Figure 6.87**, contains the modified layout and custom caption adjustments.

6. If this is a menu layout that you want to save for future use, click the disk icon above the Themes thumbnail list (**Figure 6.88**) to open a File Save dialog. Enter a name for your menu (**Figure 6.89**).

Figure 6.87 The finished menu with all adjustments applied.

Figure 6.88 Click the disk icon to save a custom menu layout for future use.

Figure 6.89 Give the custom menu a meaningful name to help you locate it in the future.

Figure 6.90 Open the Slide Options dialog, and select the Captions tab to create a caption on your slide.

Figure 6.91 Type your caption in the Captions field.

Figure 6.92 Select the Action drop-down menu in the Caption Interactivity options.

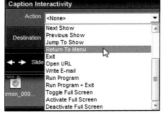

Figure 6.93 Select Return To Menu in the Action drop-down menu to assign this command to the caption.

Making Your Shows Interactive

ProShow Producer takes captioning a step further than ProShow Gold by allowing you to specify interactive features for your captions. Where Gold limits active captions to menu pages, with Producer you can make any caption respond to a mouse click.

Producer also lets you control the flow of your slide show with Pause and Resume controls, and you can even run other programs while your show is running, returning to your show when you exit the external application.

To add an interactive caption to your show:

1. Select the slide you want to place the caption on, and open the Slide Options dialog by clicking the Slide Options button in the toolbar or by double-clicking the slide. If the Captions tab is not selected, click Captions, and then select the Caption Settings (**Figure 6.90**).

2. Create your caption by entering it in the Captions field (**Figure 6.91**). In this example, I've created the caption "Return to Menu."

3. With the caption selected, click the Action drop-down menu in the Caption Interactivity controls (**Figure 6.92**). You'll see there are many options, listed in the Caption Interactivity Options sidebar.

4. Choose Return To Menu from the Action drop-down menu (**Figure 6.93**).

continues on next page

MAKING YOUR SHOWS INTERACTIVE

5. Add another caption to the slide by clicking the + button in the Captions options (**Figure 6.94**). The new caption in this example is "More About This Ship."

6. With the new caption selected, choose Open URL from the Action drop-down menu. In the Destination field, enter **http://www.princeton.navy.mil** (**Figure 6.95**).

When your show is run, highlighting of the text when the pointer hovers over the caption will indicate the active captions (**Figure 6.96**).

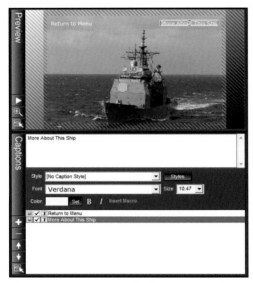

Figure 6.94 Type a new caption for a second Action command.

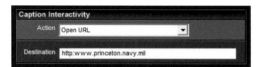

Figure 6.95 Choose Open URL from the Action drop-down menu, and enter a Web address as the destination to let viewers link from your show to a Web site.

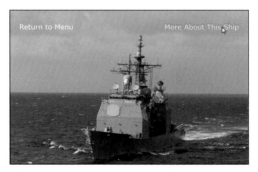

Figure 6.96 Active captions are identified by animated text when the pointer moves over the caption.

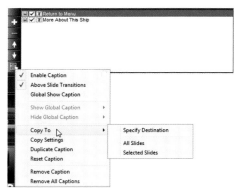

Figure 6.97 To copy a caption between slides, select the caption, and choose Copy To from the Menu button pop-up menu.

To copy an active caption to multiple slides:

1. Select the caption in the Captions list, and click the Menu button. Choose Copy To from the pop-up menu (**Figure 6.97**).

 You can copy to all slides in a show, you can copy to only the selected slides, or, if you do not have any slides selected, you can choose which slides to copy the caption to. In this example, I want the "Return To Menu" caption on all slides, so I select that option.

continues on next page

Caption Interactivity Options

A number of options are available for captions:

◆ **Toggle Pause:** Uses the same caption to toggle between Pause and Play with each click

◆ **Pause:** Pauses show

◆ **Resume From Pause:** Starts playback after pausing

◆ **Next Slide:** Advances one slide in the current show

◆ **Previous Slide**: Returns to the previous slide in the current show

◆ **Jump to Slide**: Moves to a specified slide in the current show

◆ **Next Show**: Starts playback of the next show

◆ **Previous Show**: Starts playback of the previous show

◆ **Jump To Show**: Starts playback of the specified show

◆ **Return To Menu**: Returns the viewer to the menu screen

◆ **Exit**: Stops the show and exits the player

◆ **Open URL**: Launches the default browser and navigates to the specified Web page

◆ **Write E-mail**: Launches the mail program

◆ **Run Program**: Launches the specified program

◆ **Run Program + Exit**: Launches the specified program and exits the player

◆ **Toggle Full Screen**: Toggles the display between windowed and full-screen

◆ **Activate Full Screen**: Changes the display to full-screen if current mode is windowed

◆ **Reactivate Full Screen**: Changes the display to windowed if current mode is full-screen

MAKING YOUR SHOWS INTERACTIVE

2. To copy to specific slides, choose Copy To > Specify Destination. This will open the Copy Captions dialog with the current slide selected (**Figure 6.98**).

By default, the current slide is shown in the left column, with the currently selected caption already selected.

3. To copy the selected caption, choose the slides to copy to from the Destination Slides list (**Figure 6.99**).

4. If you're copying only one caption or set of captions, you can click Copy & Close to update the selected slides and return to the Slide Options dialog. If you want to make additional copies, click the Copy button to perform the current copy, and leave the Copy Captions dialog open for more copies.

Active captions are an excellent way of letting your viewers contact you after a show. As an example, **Figure 6.100** shows a typical ending slide for a portrait show.

In this slide, I've included a "Contact Us" caption, which is linked to the Write E-mail action, and a "Visit Us on the Web" caption, which links to the home page of my portrait Web site.

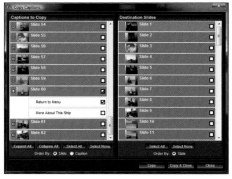

Figure 6.98 Use the Copy Captions dialog to copy a caption to specific slides in your show.

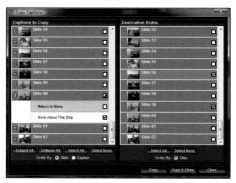

Figure 6.99 Select the caption you want to copy and the slides you want to copy to in the Copy Captions dialog.

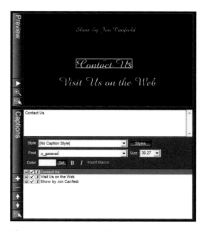

Figure 6.100 A final slide with active captions is an effective way of drawing customers after they view your shows.

Figure 6.101 Create a new show to serve as your intro show by selecting File > New Show or by clicking the New Show button in the toolbar.

Figure 6.102 Insert a new title slide for your intro show.

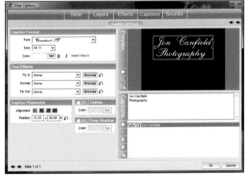

Figure 6.103 Type your caption in the Captions field.

Personalizing Your Shows

In today's competitive world, you must look for every opportunity to market yourself and your work. Your slide shows should be no different, even if they aren't for profit.

One easy way to personalize your shows is to add a custom introduction show at the start of your slide show and to add a credits slide to the end of your show.

Creating an Introduction Show

An introduction show is nothing more than a very short show—it could even be a single slide—that replaces the default "ProShow Intro."

To create a new show:

1. Choose File > New Show, or click the New Show button in the toolbar.

2. In the New Slide Show dialog, enter a name for your show, and choose the aspect ratio (**Figure 6.101**). I leave this at 4:3 (TV) since it will work with any show I create.

3. Create a title slide for your first slide by choosing Slide > Insert > Title Slide (**Figure 6.102**).

4. The Slide Options dialog will open with the Captions tab selected. Enter the text for your intro slide. In **Figure 6.103**, I've entered the company information as a single caption.

continues on next page

Enter any other caption text you want on this slide. I've added a second caption, "Presents," to my slide in **Figure 6.104**.

The advantage of multiple captions is the ability to change the format and size of each caption and to have different effects for each caption.

5. Select the main caption, and choose a text effect. In my example, I'm using the Fade Zoom Random effect for the main caption (**Figure 6.105**) and the Grow In effect for the "Presents" caption.

6. Add music to your intro show by clicking the Sounds tab of the Slide Options dialog (**Figure 6.106**).

7. Click OK to save your changes. Then click the Save button in the toolbar or choose File > Save to save the show.

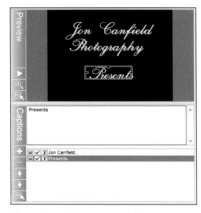

Figure 6.104 Create any additional captions for your title slide if you want.

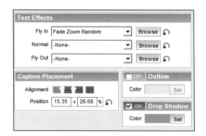

Figure 6.105 Jazz up your captions by adding text effects to them.

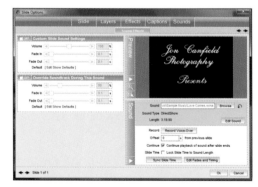

Figure 6.106 Add music or a sound effect to the intro show by selecting the Sounds tab of the Slide Options dialog.

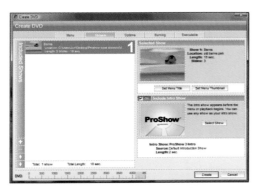

Figure 6.107 Open the Create dialog for the type of show you're creating, and select the Shows tab.

Figure 6.108 Choose your custom intro show after clicking the Select Show button in the Create dialog.

Figure 6.109 Create a blank slide and open the Slide Options dialog to access the Background settings.

8. Open your main show and click the Create Output button in the toolbar, or choose the type of show you want to create from the Create menu. I'm creating a DVD show, so I click the Shows tab of the Create DVD dialog (**Figure 6.107**).

9. Be sure the check box labeled Include Intro Show is selected, and click the Select Show button. In the File Open dialog, navigate to the folder that you saved the show in, select it, and then click Open (**Figure 6.108**).

The Shows tab of the Create dialog will now display your custom show as the one that will be used for your introduction.

To use an image background:

If you prefer to use an image background, the steps are the same, but you'll add a blank slide in this case.

1. Choose Slide > Insert > Blank Slide. Double-click the slide, or click the Slide Options button in the toolbar to open the Slide Options dialog. On the Slide tab, select Background (**Figure 6.109**).

2. Select the On/Off toggle box for "Override show background for this slide."

continues on next page

3. Click the Type: Image radio button to activate the Browse button. Click Browse, and choose Add Image File to add an image of your own, or choose Add From Media Source to add an image supplied with any of the optional Photodex MediaSource kits (**Figure 6.110**).

4. Select the image you want to use as your background, and click Open (**Figure 6.111**)

5. Add a caption.

The remaining steps are identical to those outlined earlier for using title slides.

Creating Credits Slides

The finishing touch for any show should be a credits slide. This slide should include the information on how to contact you and any necessary copyright information.

At a minimum, you'll want to give yourself copyright credit for creating the show (**Figure 6.112**).

If the photographs are from other photographers, you'll want to credit them in the same way. You should also include a copyright notice for any commercial music you are using.

Figure 6.113 shows a completed credits slide with all the details about this show.

✔ Tip

- To create the copyright symbol, hold down the Alt key while typing **0169** on the numeric keypad.

Figure 6.110 Select the source for your image—either from your own collection with the Add Image File option or from a MediaSource collection with the Add From Media Source option.

Figure 6.111 Open the image you want to use as the background for your slide.

Figure 6.112 Give yourself credit! Create a credit slide as the last slide in your show.

Figure 6.113 A completed credits slide should be a standard element of every show you create.

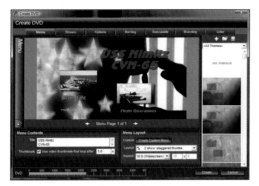

Figure 6.114 Select the type of output you want to create. To access the custom startup screen, you must choose the PC Executable file type.

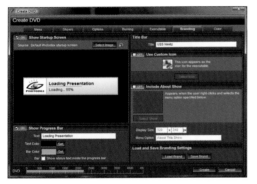

Figure 6.115 Select the Branding tab in the Create DVD dialog. Select the Show Startup Screen On/Off toggle box.

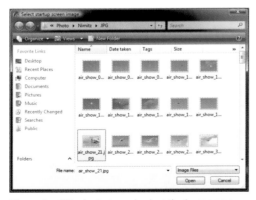

Figure 6.116 Navigate to and select the image you want to use as a background for the startup screen.

Branding Options

ProShow Producer adds more than simple personalization features to your shows. With Producer you have the ability to brand your shows for full customization. Everything from the loading screen for shows viewed on computers to renaming the title bar of the window to adding a custom "About show" page is possible with Producer.

To create a custom startup screen:

1. Select one of the Create Output options that generates a PC executable file. Available options for this type of show are DVD, Blu-ray, PC Executable, and Autorun CD. I'll use DVD for this example.

2. Click the Create Output button and choose DVD, or choose Create > DVD to open the Create DVD dialog (**Figure 6.114**).

3. Click the Branding tab.

 Make sure that the Show Startup Screen On/Off toggle box is selected (**Figure 6.115**).

4. Click Select Image, navigate to the file you want to use as the background for the startup screen, and click Open to select it (**Figure 6.116**).

continues on next page

BRANDING OPTIONS

Producer will prompt you to resize the image if necessary to fit within the 320 x 240 dimensions used by startup screens (**Figure 6.117**).

5. If you want a progress bar to display while the show loads, select the Show Progress Bar On/Off toggle box (**Figure 6.118**).

6. Change the text caption and color if you want something other than the default. I find that the default colors work well with almost every show.

7. Choose whether to display the status text (the "Loading %" numbers) in the status bar. Selecting this option increases the size of the progress bar (**Figure 6.119**).

Figure 6.117 If needed, Producer will resize the image to fit the requirements for a startup screen.

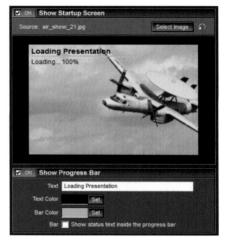

Figure 6.118 Choose whether to display a progress bar during the loading of your show.

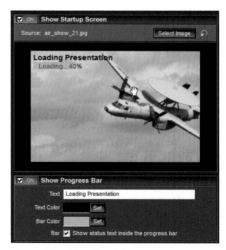

Figure 6.119 Choosing "Show status text inside the progress bar" is one available option.

Figure 6.120 Enter a custom label in the Title field.

Figure 6.121 When the show is run in windowed mode, your custom title will be used in the window title bar.

Figure 6.122 Select Image Files to look for a file to use as an icon for your shows.

Figure 6.123 A custom icon for your shows adds a professional touch to the finished product.

To change the title bar used for your show:

◆ Enter a new label in the Title field. By default, the title will be the same as your show. You can enter a new label here (**Figure 6.120**) that will be used when your show is run in windowed mode, rather than a full-screen mode where window titles are hidden (**Figure 6.121**).

To use a custom icon for your show:

◆ Make sure the On/Off toggle box for Use Custom Icon is selected. Click Select Icon to open a standard File Open dialog, and navigate to the folder containing the file you want to use as your icon.

The default file type is ICO, but you can change this by selecting the Image Files option in the lower right of the dialog (**Figure 6.122**).

After you select a file for use as the show icon, the thumbnail will be updated in the Create dialog. This is the icon viewers will see when they select your show (**Figure 6.123**).

BRANDING OPTIONS

Creating an About Show Page

The "About show" page is identical in concept to the intro show discussed earlier. This page is available when a viewer right-clicks a PC Executable show or a Web show.

To add an "About show" page:

1. Select the Include About Show box, just below the Custom Icon option.

2. Click the Select Show button, and navigate to the location that contains the show you want to use for your About show" page (**Figure 6.124**).

3. Select the "About show" page, and click Open. The show will be selected and displayed in the Create dialog (**Figure 6.125**).

4. If you want to change the default menu name from "About This Show," select the text in the field, and make any changes you like.

When viewers right-click your show and choose the menu item you named, they will see your custom "About show" page (**Figure 6.126**).

In my example, I've made the Web address an active caption that links to my Web site.

Figure 6.124 Click Select Show, and navigate to the folder that contains your "About show" page.

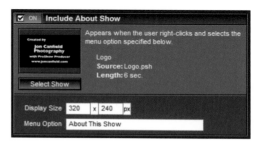

Figure 6.125 After you select a custom "About show" page, it will appear in the Include About Show options of the Create dialog.

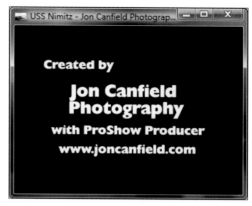

Figure 6.126 The custom "About show" page will display when the viewer right-clicks your show and chooses the menu item About This Show.

Figure 6.127 Save your brand for future use by clicking Save Brand in the Create dialog's Branding tab.

Figure 6.128 Navigate to the location to which you want to save your brand file, and click Open to save the file.

Saving Your Branding Settings

If you'll be frequently using the same or similar settings to brand your shows, you can save them for future use.

To save your branding settings:

1. Click the Save Brand button to open the Load and Save Branding Settings dialog (**Figure 6.127**).

2. Navigate to the location to which you want to save your brand file, and click Open to save the file (**Figure 6.128**). In the future, you can apply all the branding settings—custom startup screen, progress bar, title bar, custom icon, and custom "About show" page—by clicking Load Brand and choosing the branding file you created.

Don't forget that examples for all of the options covered in this chapter are available at the companion Web site on the Chapter 6 page at *www.proshowbook.com/chapter6*.

✔ Tip

- Photodex has a number of ProShow MediaSource packages available, each with a different theme. The DVDs include templates, menus, royalty-free music, backgrounds, borders, and title slides.

BRANDING OPTIONS

TEMPLATES AND STYLES

7

One way to add consistency to your shows is by using a template that contains all the slide formatting and information you need to create a show. Styles are another great time-saver. These premade settings let you apply advanced formatting and motion effects with a click of the mouse.

Both ProShow Gold and ProShow Producer include templates and styles. If you use ProShow Producer, you can even create your own templates for export.

Using Templates

Templates are great starting points for your shows. Especially when you're learning ProShow, using a template can help you create some of the effects you've seen in demo shows and online shows. Of course, although you can use them as is, you can also modify them to suit your own needs.

Loading a Show Template

ProShow includes a number of templates that are installed automatically with the program.

To use a show template:

1. Choose Show > Show Templates > Open Template (**Figure 7.1**).

2. When the Load Show Template dialog opens, you'll see the installed templates listed (**Figure 7.2**).

3. In this dialog, you can select a template by clicking it, which will show you the template name and a description of the template.

4. Click Load to load the selected template. This opens the template, with placeholder slides ready for you to add content to your show (**Figure 7.3**).

Figure 7.1 Choose Open Template from the Show > Show Templates menu to get started using an existing template.

Figure 7.2 The Load Show Template dialog gives you access to all the installed templates, along with the template name and a description.

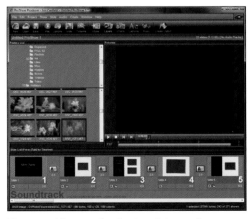

Figure 7.3 After opening the template, you have a show that is ready for your content.

USING TEMPLATES

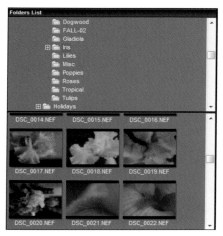

Figure 7.4 Use the Folders List to navigate to the folder that contains the images you want to use in your show.

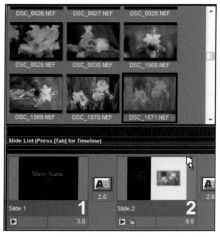

Figure 7.5 Click the image thumbnail you want to use, and drag it to the Slide List.

Figure 7.6 When the image is over the placeholder, release the mouse button to replace the placeholder with your selected image.

Adding Content to Your Template Show

Once your template is opened, use the Folders List to navigate to the folder containing the images you want to use in your show (**Figure 7.4**).

To access the folder containing your images:

1. Click the folder in the Folders List to display the thumbnails for files in that folder.

2. Click the thumbnail of the image you want to use in your show, and drag it to the first image slide (**Figure 7.5**).

3. When the image appears in place of the placeholder, release the mouse button to place the image on that slide (**Figure 7.6**).

Placing Images on Multilayer Slides

Many of the slides in a template will have multiple layers and are designed to hold more than one image. On a simple layout, like the one shown in **Figure 7.7**, you can use the method mentioned earlier, dragging and dropping your images onto each placeholder.

In more complex layouts, it's much easier to use the Slide Options dialog to place content on a slide.

To add images to a slide:

1. Click the slide you want to add content to and then click the Slide options toolbar button (**Figure 7.8**). Alternatively, you can double-click the slide in the Slide List to open the dialog.

2. Click the Layers tab to access the layer settings for this slide (**Figure 7.9**).

3. Select the first image placeholder layer by clicking it in the Layers list (**Figure 7.10**).

Figure 7.7 If the layout isn't too complex, you can drag and drop your images directly onto the placeholders in the Slide List.

Figure 7.8 For more complex layouts, it's easiest to work from within the Slide Options dialog to add images to placeholders.

Figure 7.9 Select the Layers tab in the Slide Options dialog to access the placeholders.

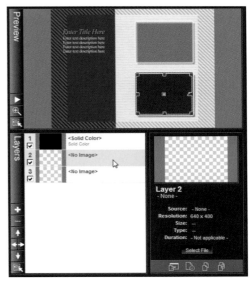

Figure 7.10 Select the placeholder layer by clicking it in the Layers list.

USING TEMPLATES

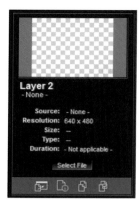

Figure 7.11 Click Select File to open an Open File dialog and navigate to the folder that contains your images.

4. Click the Select File button to open a standard Open File dialog, and navigate to the folder that contains your images (**Figure 7.11**).

5. Select the file, and click OK. The image will be moved onto the slide, replacing the placeholder for that layer (**Figure 7.12**).

6. Repeat this for the other layers on the slide.

✔ Tips

■ Most templates reserve the first slide for titles. The first image placeholder will normally be found on the second slide.

■ You can also right-click the image layer to access the Select File option.

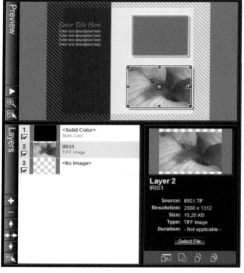

Figure 7.12 After you select the image, it will replace the placeholder for that layer.

Modifying Template Settings

Since a template functions as a show once you open it, you can make any adjustments that you like to all aspects of the show. If you like the general template but you're not pleased with the timing and transitions, it's a simple task to change these items. Just as with a show you created from scratch, select the slide or slides you want to change, and then change the settings to the new values. As an example, in **Figure 7.13**, I'm starting with a template slide with a duration of four seconds and a wipe transition.

By clicking the slide in the Slide List, I can change the duration by entering a new value (**Figure 7.14**), and I can change the transition by clicking the Transition icon and selecting a new transition in the Choose Transition dialog (**Figure 7.15**).

Figure 7.13 This template uses a four-second duration with a wipe transition. I want to change the duration and transition for my show.

Figure 7.14 Entering a new value in the Duration field changes the timing of the selected slide.

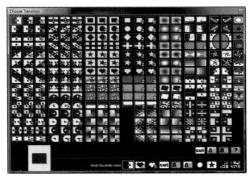

Figure 7.15 Clicking the Transition icon opens the Choose Transition dialog, where I can select a new transition for the selected slide.

Figure 7.16 Selecting Show > Show Templates > Open Template is the only way to open a template file.

Figure 7.17 Templates are simply shows with the content removed. Placeholders are used to add content to the show.

Creating Templates

A ProShow template is, at its most basic, your show with all the slide content removed. Think of a template as an outline. When you create a template, ProShow saves all the show settings to be reused again in a new show. When you use the template, all the formatting is automatically applied to your show.

But a template is not the same as a show file. A template file has a .pst file extension and can be opened only by choosing Show > Show Templates > Open Template (**Figure 7.16**). When the template is opened, you have a new show sans content. Where the images would normally be, you'll see placeholders in both the preview panel and the thumbnails in the Slide List identifying where images will be displayed when placed on the slide (**Figure 7.17**).

Templates contain the following settings:

◆ Slide number

◆ Slide order

◆ Slide position

◆ Transitions

◆ Motion effects

◆ Editing adjustments

◆ Image effects

◆ Background settings

◆ Captions

◆ Caption motion

◆ Soundtrack and slide sound settings

◆ Control settings

Creating an Empty Template

To create a show template, start with a finished show. Before saving as a template, you need to make sure that all images are replaceable to keep them from being included in the template when it's created.

ProShow will handle this for you by removing all content during the save process.

To create a template with a finished show:

1. Choose Show > Show Templates > Save as Template (**Figure 7.18**), or click the Create button in the toolbar and select the Show Template option (**Figure 7.19**).

2. You'll be warned that saving as a template will remove all content from the show, and you'll be asked to confirm that that's what you really want to do (**Figure 7.20**).

Figure 7.18 Choose Show > Show Templates > Save Template to create a template file for future use.

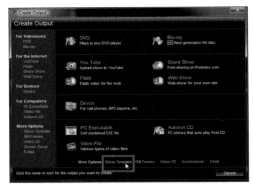

Figure 7.19 You can also create a template from the Create Output dialog by selecting the Show Template option.

Figure 7.20 Confirm that you want to remove all content to create your template.

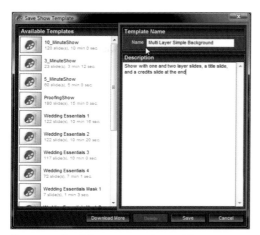

Figure 7.21 Providing your templates with an accurate name and description will make selecting them easier in the future.

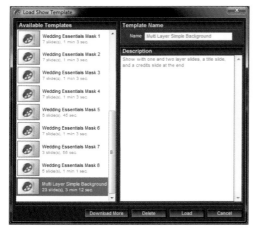

Figure 7.22 After you save the new template, ProShow adds it to the list of available templates.

Figure 7.23 Open the Slide Options dialog by double-clicking the slide in the Slide List or by clicking the Slide button in the toolbar.

3. In the Save Show Template dialog, give your template a useful name and description to help you identify the template in the future (**Figure 7.21**).

4. Click Save to save your template. ProShow will automatically save your template and add it to the list of available templates in the Load Show Template dialog (**Figure 7.22**).

Creating a Template with Content

Templates don't have to be empty shells with no content in place. You can also create a template that retains the music, sounds, and any images that you want, but it takes a little more effort on your part.

Begin by opening the show file that you want to convert to a template. Any show can serve as the basis for a new template.

To convert a show into a template:

1. Each layer and image that you want to keep in the template must be specified. With the slide selected, click the Slide button in the toolbar, or double-click the slide in the Slide List (**Figure 7.23**).

continues on next page

2. Select the Layers tab to access the options for each layer of the slide (**Figure 7.24**).

3. Select the first layer you want to keep the image in and deselect the Replaceable Image check box in the Template Settings controls (**Figure 7.25**).

4. Repeat for each layer and slide that will include an image.

5. Save the template as you did earlier in this chapter in the "Creating an Empty Template" section.

6. The template now appears in the Slide List as a new show, with only the selected images displayed; any other slides will display the placeholder for new content (**Figure 7.26**).

7. Immediately save your show by choosing File > Save (**Figure 7.27**).

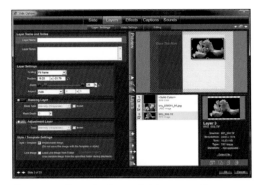

Figure 7.24 Open the Layers tab to access the settings for slide layers.

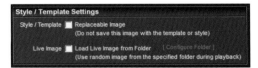

Figure 7.25 Choose the layer you want to place an image in that will be included with the template and deselect the Style/Template: Replaceable Image check box.

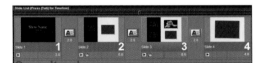

Figure 7.26 The Slide List will show your updated slides with their content and placeholders.

Figure 7.27 Save the show to prepare for the conversion to a template.

Figure 7.28 Choose File > Collect Show Files to copy all content to a single location for easier access.

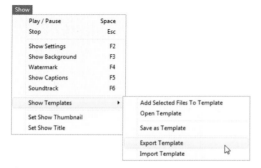

Figure 7.29 Choose Show > Show Templates > Export Template to save your newly modified template.

Figure 7.30 Choose the template name you used in step 5, and save the template with the collected files.

8. Choose File > Collect Show Files to open the Collect Show Files dialog (**Figure 7.28**). This will gather all the files that are in your show into a single location.

9. Click the Browse button in the Copy to Folder options, navigate to the location where you want to save the files needed for your template, and click OK.

10. Choose Show > Show Templates > Export Template (**Figure 7.29**).

11. Choose the template name from the list, save it to the folder you placed the collected show files in (**Figure 7.30**), and click Save.

To distribute this template, copy all the files to the new computer. Because ProShow has placed all the needed files in a single directory, this is easy to do, especially if you use an archive utility, such as WinZip or StuffIt to compress the files into a single package. You can download WinZip from *www.winzip.com*, and you can download StuffIt from *www.stuffit.com*.

✔ Tips

- Create a new folder for every template that you save in this fashion to make it easier to select all the files needed for this template to work correctly.

- Use a ZIP file with the self-extracting archive feature to make it easier for people to use your templates after downloading them to their computers.

CREATING TEMPLATES

Using Styles

Styles are essentially templates with a single slide. All the same properties can be applied to a style or a template, but you have only the single slide to work with rather than the entire set of slides in your show.

To get started with using styles, select any slide in the Slide List and click the Styles button ![Styles] in the toolbar, or choose Slide > Slide > Slide Styles (Ctrl+F1).

This will open the Slide Options dialog with the Slide Styles tab selected (**Figure 7.31**).

In the upper left of the dialog, you'll see a live preview of the effects that are part of that style, along with a description, the number of layers, and the optimal timings for the style (**Figure 7.32**).

The Slide Styles list (**Figure 7.33**) shows you all the installed styles you have to select from. Above the list are three drop-down menus to help with filtering the styles shown.

Figure 7.31 The Slide Styles tab in the Slide Options dialog is where you'll set the style for your slide.

Figure 7.32 The selected style will show a live preview along with information on the settings for this style in the upper left of the dialog.

Figure 7.33 The Slide Styles list shows all the installed styles that are available for use.

Figure 7.34
You can reduce the number of styles to browse by selecting a category from the drop-down menu.

Figure 7.35 Options in the aspect ratio drop-down menu filter the styles to fit a particular screen format.

Figure 7.36 The layers drop-down menu lets you select only those styles with a particular number of layers.

From the drop-down menus, you can filter by category (**Figure 7.34**), by aspect ratio (**Figure 7.35**), or by number of layers (**Figure 7.36**).

You can combine filters to further reduce the number of styles. For example, in **Figure 7.37**, I've asked ProShow to show me only the complex montages that fit the 4:3 aspect ratio and use two layers.

continues on next page

Figure 7.37 In this example, multiple filters are applied, directing ProShow to show only complex montages that use the 4:3 aspect ratio with two layers.

USING STYLES

To apply a style to your slide, select it in the Slide Styles list, and click the Apply button. The selected style will show a check mark by the name to help you identify which is being used (**Figure 7.38**).

If the selected style will change existing settings or it uses a different aspect ratio than your current slide, you'll be prompted to confirm that you want to change to the new style (**Figure 7.39**).

✔ Tip

- Make sure the layers are in the order you want before applying the style to your slide. It's much less work to change the format of a slide before applying a style.

Figure 7.38 The selected style is shown with a check mark to identify it.

Figure 7.39 ProShow will ask you to confirm your changes before applying them to the slide.

Figure 7.40 To assign a style to your slide, click the Styles button in the toolbar, or choose Slide > Slide > Slide Styles from the menu.

Figure 7.41 Click Create to open the Create Slide Style dialog.

Figure 7.42 Use the Create Slide Style dialog to enter information about your new style.

Figure 7.43 After you create your new style, it will appear in the list of available slide styles.

Creating Original Styles

Along with using the provided styles, you can create your own styles for personal use or to share with others.

To create a new style, begin by formatting your slide the way you want it to look, including all layers, motion effects, and captions. When the slide is complete, click the Styles button in the toolbar (**Figure 7.40**), or choose Slide > Slide > Slide Styles (Ctrl+F1).

In the Slide Options dialog, the Slide Styles tab will be selected. Click the Create button in the upper-left corner of the dialog where the live preview is (**Figure 7.41**).

In the Create Slide Style dialog (**Figure 7.42**), enter a name, category, and description for your style to help identify the style for future use. If you plan to share the style, it's a good idea to also include your name and Web address as the publisher in order to retain credit for the style and to enable people to contact you.

Selecting the Aspect Ratio check box will allow the use of the style with any aspect ratio slide, rather than restricting it to the aspect ratio used on the source slide.

When the Compatibility check box is selected, ProShow will remove any ProShow Producer–only features so that your style will also work with ProShow Gold.

To save your settings, click OK. The new style will be added to the list of available styles (**Figure 7.43**).

continues on next page

CREATING ORIGINAL STYLES

You can add more styles by clicking Manage Styles (**Figure 7.44**). Clicking this button will open a new dialog with options for working with styles (**Figure 7.45**).

To import a new style you've downloaded or received, click Import to open a standard Open File dialog (**Figure 7.46**). Navigate to the folder that contains the style you want to import, and click Open.

Figure 7.44 Click Manage Styles to work with existing styles or to import new styles.

Figure 7.45 The Manage Slide Styles dialog has options for importing, exporting, downloading, and removing styles.

Figure 7.46 Navigate to the folder that contains the style you want to import and click Open. The new style will be added to the Style List.

Figure 7.47 Navigate to the folder you want to save the exported style to, and click Save.

Figure 7.48 Use the Edit Slide Style dialog to make changes to the description, name, and other basic information about the style.

Figure 7.49 You'll be prompted to confirm your request to delete a slide style.

To export a style, click Export to open a standard File Save dialog (**Figure 7.47**). Navigate to the folder that you want to save the style to, and click Save.

To edit a style description and set the visibility of the style, click Edit to open the Edit Slide Style dialog (**Figure 7.48**). There you'll find options to change the name, category, and description of the style, as well as choose whether the aspect ratio is fixed or the style can be used with any aspect ratio. You can also choose to hide the style so that it doesn't appear in the Slide Styles list.

Clicking Remove in the Manage Slide Styles dialog will remove the style from the Slide Styles list and remove it from your computer. You will be prompted to confirm this request (**Figure 7.49**). Click OK to delete, or click Cancel to keep the style.

continues on next page

To download additional styles from the Photodex Web site, click Download in the Manage Slide Styles dialog. ProShow will connect to the Photodex site and display a list of additional content that can be downloaded to your computer (**Figure 7.50**).

✔ Tip

■ To convert a template into a style, select any slide in a template, and follow the steps listed here. The new style will inherit the properties of that slide.

Figure 7.50 You can download a variety of new content from the Photodex Web site through the Download Content dialog.

PUTTING IT
OUT THERE

A show doesn't do much good sitting on your hard drive, so after all that work putting your masterpiece together, it's time to create the output that will let you share your slide show with the rest of the world, or just your family—it's entirely up to you.

In this chapter, we'll cover the different output options for your slide shows. With ProShow you can output your shows for viewing on everything from Blu-ray high-definition discs to the Web to mobile phones. We'll also explain how to protect your shows from being copied or viewed without permission.

Choosing Options for Show Types

Both ProShow Gold and ProShow Producer offer a wide array of options for outputting your shows (**Figure 8.1**). Along with CDs and DVDs, you can create high-resolution Blu-ray discs.

For use on a computer, you can create a Flash video, a YouTube show that will automatically upload for you, or a Web show that you can host on your own site. Or you can take advantage of the free sharing offered on the Photodex.com Web site.

In addition to these options, you can create an executable file (one that doesn't need any other programs to operate), an autorun CD that plays when inserted into a computer, a screen saver, or an e-mail show.

Finally, in an obvious recognition of the popularity of portable gadgets and gaming systems, you can even create shows for playback on cell phones, game consoles such as the Nintendo Wii, Apple iPods, and TiVo boxes.

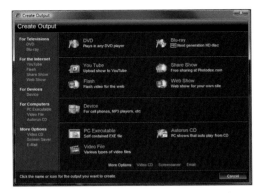

Figure 8.1 Both ProShow Gold and ProShow Producer offer the most output options of any presentation program available. You can output your show to everything from a Blu-ray disc to a cell phone.

Figure 8.2 ProShow Gold offers the same output options as ProShow Producer but eliminates the Branding and Color tabs.

Figure 8.3 ProShow Producer adds options to use color management for your shows and to brand them with a custom startup screen, an icon, and status text.

Creating Shows for DVDs and Blu-ray Discs

CDs and DVDs are popular output choices for slide shows. They can be played on any TV with a DVD player or on most computers, giving you the greatest amount of flexibility.

Aside from the obvious advantage of space—a DVD has the capacity to hold 4.7 GB of data compared with 700 MB for a CD—using a DVD for your output offers other benefits. Thanks in part to its better transfer rates, a DVD allows for much higher image resolution and therefore more detail when viewed onscreen. **Table 8.1** shows the different resolutions supported by the various DVD and CD formats.

Another limitation to consider with CD is the playback rate. It will be difficult to keep your transitions and music in sync, so it's important to presize your images and simplify the transitions and layers.

DVDs

To create a DVD, begin by clicking the Create Output button in the toolbar and choosing DVD, or choose Create > DVD. If you haven't saved your show yet, you'll be prompted to do so before you can create the DVD. The Create DVD dialogs in ProShow Gold (**Figure 8.2**) and ProShow Producer (**Figure 8.3**) differ only slightly. ProShow Producer adds two tabs to the dialog: Branding, which was covered in Chapter 6, and Color, which lets you set color management options by applying specific profiles for your show.

continues on next page

Table 8.1

Image Resolutions on Disc	
MEDIA	RESOLUTION
VCD	352 x 240
DVD	720 x 480
Blu-ray	1920 x 1080

CREATING SHOWS FOR DVDS AND BLU-RAY DISCS

When you open the Create DVD dialog, you'll see the Menu tab. In the preview panel, the first slide in your show will appear as a thumbnail, along with the slide's title place-holder. The first step is to change the name to something that suits the show. In **Figure 8.4**, I've changed the name of this show to *Bodie* (a ghost town in the Sierra Nevada of California).

You'll need to decide whether your show will use a wide-screen aspect ratio or the stan-dard TV ratio. Wide-screen, with an aspect ratio of 16:9, is the default and, when shown on a high-definition TV or wide-aspect com-puter monitor, will fill the screen completely. The 4:3 TV aspect ratio is a better option if you know the show will not be viewed on a high-definition TV.

At the lower left of the Create DVD dialog, you'll see the size bar letting you know whether you have enough space on the media for your show (**Figure 8.5**).

Use the Shows tab to add shows to or remove shows from the DVD (**Figure 8.6**). To add a show, click the plus (+) button and navigate to the show you want to add. Once the show has been added, you can change the order by using the up and down arrows. The size bar will update to indicate the amount of space now in use by all the DVD content.

For this show, I've also added a custom intro show that consists of a single title slide (see Chapter 6 for details on making an intro show).

Figure 8.4 Be sure to change the name of your show, if you haven't already, to something more meaningful than Untitled.

Figure 8.5 The size bar indicates how much space your show will be using on the selected media. In this example, I'm using about 400 MB of space.

Figure 8.6 The size bar is updated when you add new content—in this case a second show—to the DVD.

Figure 8.7 The Options tab is where you'll find the quality and format settings.

Figure 8.8 The Burning tab includes all the settings for creating the DVD, such as how many copies to make and whether to add other files to the DVD.

Table 8.2

DVD Quality Settings		
SETTING	QUALITY	CAPACITY
DVD HQ (High Quality – Maximum)	Highest	1 hour
DVD HQ Save	Very High	1 hour
DVD SP	High	2 hours
DVD LP	Very Good	3 hours
DVD EP	Good	4 hours
DVD SLP	Low	6 hours
DVD SEP	Low	8 hours

If you're in North America, the video standard is NTSC, while much of the rest of the world uses the PAL standard.

The Options tab is where you'll set the quality and format information for your show (**Figure 8.7**).

The DVD Type drop-down menu offers seven quality options, each determining how much content will fit on your DVD and how high the quality will be on playback. **Table 8.2** lists the quality and approximate capacity for each quality setting.

Leave the Audio Type drop-down menu set to MP2. Under DVD Output Options, I suggest leaving the Anti-Flicker check box and the Desaturation check box selected. Anti-Flicker will prevent flickering that appears on some images. It costs you a little bit of sharpness, but typically you won't notice a difference. The flickering, however, I guarantee you'll notice!

Desaturation lets you reduce the saturation of images. The default setting reduces saturation by 20 percent, which helps prevent an unnaturally vibrant color, especially when viewing your show on TVs.

The Video Clip Output Options area offers two choices for the Encoding Quality setting: Normal and High. Unless your show includes video, this setting does not affect your show. High quality will improve the look of videos, but it comes at the expense of file size and a possible loss of smooth playback, depending on the device on which the show is playing.

The Burning tab (**Figure 8.8**) has all the options that control what is actually put onto the DVD when you create it. If you have multiple DVD writers on your computer, you can select from the drop-down list of available devices. You can also choose ISO Image File, which creates a disc image that can be burned later.

continues on next page

CREATING SHOWS FOR DVDS AND BLU-RAY DISCS

The options on the Burning tab also allow you to simulate the burning of a disc to verify that everything is set up properly and whether to include the original files or other content on the DVD. I'll often include order forms and digital proof sheets on a DVD that is prepared for a client—it provides them with an easy way to order additional prints.

The Executable tab (**Figure 8.9**) offers an option to place an autorun file on the DVD that will start your show automatically when the disc is inserted into a computer. Select the Include PC Autorun on Disk option (Windows only).

In addition to the options available in ProShow Gold, ProShow Producer has one additional option in the Executable Startup section—the ability to select which monitor the show runs on in multiple-monitor settings. For example, you might be in a studio, so you can specify that the show run in a continuous loop on a large projection screen or wall-mounted display. Or, when giving presentations, you might want your laptop display to show your speaker notes while the show plays on a projector.

In the Protection section, you can add an autorun file to the DVD to limit the number of times the show will run by either days or times run (and you can set both options if you like).

You can also add a password to prevent unauthorized viewers from running the show, and you can add information about how to contact you after the executable expires (**Figure 8.10**).

Branding, which was covered in Chapter 6, lets you replace the default Loading Presentation screen with one of your own (**Figure 8.11**). This option is available in ProShow Producer only.

Figure 8.9 If you want to include an autorun file on your disc or want to password-protect the show, you'll find these options on the Executable tab.

Figure 8.10 By limiting the time your show can be viewed, you encourage clients to make their selections early.

Figure 8.11 You can replace the standard loading screen with one of your own if you're using ProShow Producer.

Figure 8.12 The Color tab (ProShow Producer only) lets you select the color profiles to be used when playing your shows.

Figure 8.13 If you know that your show will be played on a specific device that has been calibrated, you can use the profile for that device to ensure that colors are accurately displayed.

The final tab in the Create DVD dialog (for ProShow Producer) is Color (**Figure 8.12**). Color management is a serious concern for professional photographers, but it should be important to everyone. After all, you want your work to look its best regardless of where it's being viewed.

The Color tab allows you to specify what color profile will be used when the show is played back. You can select a profile for video use and one for computer playback. Unless you know that your show will be displayed on the specified devices, though, you're better off leaving these options deselected and defaulting to sRGB, which is typically used by computers and works well with TVs also.

To select a specific profile for playback, click the On/Off toggle box to enable the Use Color Profiles for Video settings.

Next, select Use Installed if the profile is on your computer, or select Use Custom if you'll be using a profile from another computer or display device (**Figure 8.13**).

Finally, click the Create button. ProShow will prepare all the show content and begin to burn the DVD for output, or it will create an ISO image file that you can burn to a disc later.

✔ Tips

- Most wide-screen monitors actually have a 16:10 aspect ratio. This will stretch your images slightly, but the change is minimal and probably won't be noticed.

- Using MP2 will save you some disc space over the PCM format. The disadvantage is that PCM will have slightly better audio quality. If space is not a concern, PCM is a good choice.

Blu-ray Discs

To create a Blu-ray disc, begin by clicking the Create Output button in the toolbar and then choose Blu-ray, or choose Create > Blu-ray [HD]. If you haven't saved your show yet, you'll be prompted to do so before you can create the disc. The Create Blu-ray dialogs in ProShow Gold (**Figure 8.14**) and ProShow Producer (**Figure 8.15**) differ only slightly. Producer adds two tabs to the dialog: Branding, which was covered in Chapter 6, and Color, which lets you set color management options by applying specific profiles for your show.

When you open the Create Blu-ray dialog, you'll see the Menu tab. In the preview panel, the first slide in your show will appear as a thumbnail, along with the slide's title placeholder. The first step is to change the name to something that suits the show (**Figure 8.16**).

You'll need to decide whether your show will use a wide-screen aspect ratio or the standard TV ratio. Blu-ray uses 720p, 1080i, and 1080p for wide-screen use with an aspect ratio of 16:9. The default, 1080p, is the highest-quality setting. The 480i and 576i types both use the 4:3 TV aspect ratio and are a better option if you know the show will not be viewed on a high-definition TV.

HD uses two different methods of refreshing a screen. Progressive scan—the *p* in 1080p— is the highest quality and refreshes the entire screen with each pass. Interlaced scan—the *i* in 1080i—refreshes every other line on each pass, requiring two passes to fully refresh the display. If you're not sure which to use, choose the progressive setting. The Blu-ray player will handle the rendering into interlaced mode if needed.

Figure 8.14 ProShow Gold offers the same output options as ProShow Producer but omits the Branding and Color tabs.

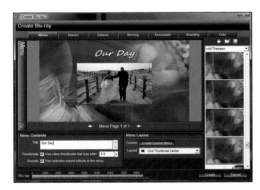

Figure 8.15 ProShow Producer adds options to use color management for your shows and to brand them with a custom startup screen, icon, and status text.

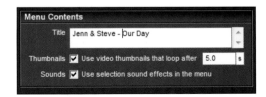

Figure 8.16 You'll want to give your show a descriptive name for the main menu screen. I've changed the name of this show to Jenn & Steve – Our Day.

Figure 8.17 The size bar indicates how much space your show will be using on the selected media. In this example, I have more data than I can fit on a single disc with the selected resolution of 1080p.

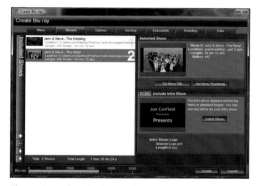

Figure 8.18 The size bar updates when you add new content, in this case a second show, to the disc.

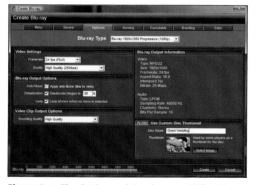

Figure 8.19 The Options tab is where you'll find the quality and format settings.

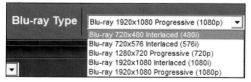

Figure 8.20 Selecting a different quality option (on the Options tab in the Blu-ray Type drop-down menu) can free up space if your show is too large for the disc.

At the lower left of the Create Blu-ray dialog, you'll see the size bar indicating whether you have enough space on the media for your show. As the example in **Figure 8.17** shows, the green represents the space used on the disc, and any red indicates that you are over the limit for what can fit on the disc. If you see any red, you'll need to use a different resolution or quality setting.

If your show is too large for the media, you'll need to either reduce the resolution of the show or remove content from the show.

The Shows tab is where you add shows to or remove shows from what you create on the Blu-ray disc (**Figure 8.18**). To add a show, click the plus (+) button and navigate to the show you want to add. Once the show is added, you can change the order by using the up and down arrows. The size bar will update to show you the amount of space now in use by all content on the disc.

For this show, I've also added a custom intro show, which consists of a single title slide (see Chapter 6 for details on making an intro show).

On the Options tab, you can set the quality and format information for your show (**Figure 8.19**).

The Blu-ray Type drop-down menu (**Figure 8.20**) offers five quality options, each determining how much content will fit on your

continues on next page

disc and how high the quality will be on playback. **Table 8.3** lists the quality and approximate capacity for each quality setting.

Depending on the Blu-ray type you select, the Framerate and Quality options in the Video Settings options will vary (**Figure 8.21**). The highest-quality setting, 1080p, has a frame rate of 24 frames per second (fps), the same as film.

I suggest leaving the Anti-Flicker check box and the Desaturation check box selected. Anti-Flicker will prevent flickering that might appear on some images. It costs you a little bit of sharpness, but typically you won't notice a difference.

Desaturation allows you to reduce the saturation of images. The default setting reduces saturation by 20 percent, which helps prevent an unnaturally vibrant color, especially when viewing your show on TVs.

The Video Clip Output Options area offers two choices for Encoding Quality: Normal and High. Unless your show includes video, this setting does not affect your show. High quality will give videos a better look but at the expense of file size and possible loss of smooth playback, depending on the device on which the show is being played.

The Burning tab (**Figure 8.22**) includes all the options that control what is actually put onto the disc when you create it. If you have multiple disc writers on your computer, you can choose from the drop-down list of available devices. You can also choose ISO Image File, which will create a disc image that you can burn later.

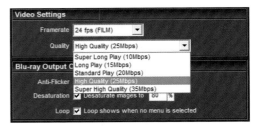

Figure 8.21 The Quality setting can free up disc space when needed.

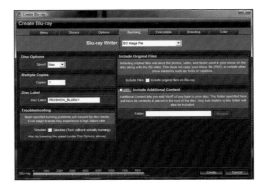

Figure 8.22 The Burning tab has all the settings for creating the Blu-ray disc, including how many copies to make and whether to add other files to the disc.

Table 8.3

SETTING	RESOLUTION	QUALITY
Blu-ray Quality Settings		
1080p	1920 x 1080	Best
1080i	1920 x 1080	Very High
720p	1280 x 720	High
576i	720 x 576	Good
480i	720 x 480	Good

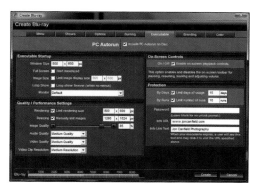

Figure 8.23 If you include a Windows autorun file on the disc, the show will play automatically when the disc is inserted into a Windows computer.

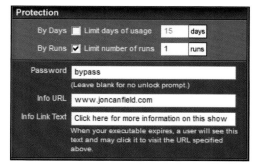

Figure 8.24 ProShow enables you to password-protect your shows and to provide contact information in the form of a URL and text that can be used to contact the author.

Figure 8.25 You can replace the standard loading screen with one of your own if you're using ProShow Producer.

The options on the Burning tab allow you to simulate the burning of a disc to verify that everything is set up properly and whether to include the original files or other content on the disc. I'll often include order forms and digital proof sheets on a disc that is prepared for a client—it provides them with an easy way to order additional prints.

The Executable tab (**Figure 8.23**) lets you place an autorun file on the disc that will start your show automatically when you insert the disc into a computer (Windows only).

ProShow Producer offers one additional option here—the ability to select which monitor the show runs on in multiple-monitor settings. For example, you might be in a studio, so you can specify that the show run in a continuous loop on a large projection screen or wall-mounted display. Or, when giving presentations, you might want your laptop display to show your speaker notes while the show plays on a projector.

When adding an autorun file to the disc, you can protect your shows by limiting the number of times the show will run by either days or times run (and you can set both options if you like).

Also in the Protection section, you can add a password to prevent unauthorized viewers from running the show, and you can add information about how to contact you after the executable expires (**Figure 8.24**).

Branding, which was covered in Chapter 6, lets you replace the default Loading Presentation screen with one of your own (**Figure 8.25**). This option is available in ProShow Producer only.

continues on next page

The final tab in the Create Blu-ray dialog (for ProShow Producer) is Color (**Figure 8.26**). Color management is a serious concern for professional photographers, but it should be important to everyone. After all, you want your work to look its best regardless of where it's being viewed.

The Color tab allows you to specify what color profile will be used when the show is played back. You can select a profile for video use—this option will display only when the show contains video—and one for computer playback. Unless you know that your show will be displayed on the specified devices, though, you're better off leaving these options deselected and defaulting to sRGB, which is typically used by computers and also works well with TVs.

To select a specific profile for playback, click the Off/On toggle box to enable the Use Color Profile settings. If your show includes video, you can set a separate color profile to be used for video than you would use on a computer for playback.

Next, select Use Installed if the profile is on your computer, or select Use Custom if you'll be using a profile from another computer or display device (**Figure 8.27**).

Finally, click the Create button. ProShow will prepare all the show content and begin to burn the DVD for output or create an ISO image file that you can burn to a disc later.

Figure 8.26 The Color tab (ProShow Producer only) lets you select the color profiles to be used when playing your shows.

Figure 8.27 If you know that your show will be played on a specific device, such as a calibrated monitor or a projector, you can use the profile for that device to ensure that colors display accurately.

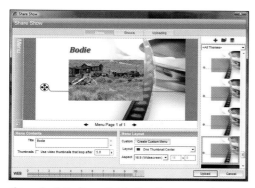

Figure 8.28 ProShow Gold offers the same output options as ProShow Producer but eliminates the Branding and Color tabs.

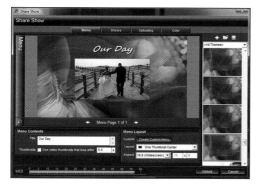

Figure 8.29 ProShow Producer adds options to use color management for your shows and to brand them with a custom startup screen, icon, and status text.

Figure 8.30 You'll want to give your shows a descriptive name for the main menu screen. Here I've used Jenn & Steve – Our Day.

Creating Online Shows

One of the great features of the Internet is the ability to share files with anyone regardless of where they are. ProShow supports several ways of sharing your show online and via e-mail.

Share Shows

If you don't have a Web site of your own or you just don't want to bother with creating a Web page and hosting your show, Photodex will host your show for you, at no charge, on its Web site.

To create a share show, begin by clicking the Create Output button in the toolbar and choosing Share Show, or choose Create > Share Show. If you haven't saved your show yet, you'll be prompted to do so before you can create the disc. The Create Share Show dialogs in ProShow Gold (**Figure 8.28**) and ProShow Producer (**Figure 8.29**) differ only slightly. Producer adds two tabs to the dialog: Branding, which was covered in Chapter 6, and Color, which lets you set color management options by applying specific profiles for your show.

When you open the Share Show dialog, you'll see the Menu tab. In the preview panel, the first slide in your show will appear as a thumbnail, along with the slide's title placeholder. The first step is to change the name to something that suits the show (**Figure 8.30**).

You'll need to decide whether your show is going to use a wide-screen aspect ratio or the standard TV ratio. Base the decision for which aspect ratio to select on the images you're using in your show. If your photos are in a standard 4:3 dimension, using a wide-screen aspect ratio will leave more empty space on either side of the show and increase the file size.

continues on next page

On the Shows tab (**Figure 8.31**), you can add or remove shows from what will become your final online show. To add a show, click the plus (+) button and navigate to the show you want to add. Once the show has been added, you can change the order by using the up and down arrows. The size bar will update to show you the size of your show on upload.

For this example, I've added a custom intro show that consists of a single title slide (see Chapter 6 for details on making an intro show).

The Uploading tab (**Figure 8.32**) is where you'll enter your account information and select which album to store your show in.

You'll need to enter your Photodex member name and password information. If you don't already have an account, you can create one by clicking Create Account, which will connect you to the Photodex Sharing Web site (**Figure 8.33**).

Figure 8.31 The size bar updates when you add new content to the disc.

Figure 8.32 The Uploading tab is where you'll find the login and privacy settings.

Figure 8.33 To post your shows on the Photodex Sharing service, you'll need to create a free account by clicking the Create Account button in the Uploading panel of the Create Share Show dialog.

Figure 8.34 The Photodex Sharing site allows you to group your shows into albums that can be public or private.

Figure 8.35 If you're using ProShow Producer, you can set color profile options for the playback of your show. Unless you know the show will be played on a specific device and profile, it's best to leave this set to Use Default.

Figure 8.36 ProShow will render your show and begin the upload process to the Photodex Sharing site when you click Upload.

The Photodex Sharing site lets you group your shows into albums, making it easier to organize multiple shows by types and to protect some shows and not others (**Figure 8.34**).

You can also set restrictions on who can view your show. The Mature Content option will prevent anyone from viewing your show without a password.

Selecting the Privacy check box keeps your show from being visible to anyone other than you. This is useful for testing your show before releasing it for public viewing.

The final tab in the Share Show dialog (for ProShow Producer) is the Color tab (**Figure 8.35**). This option lets you set a particular color profile. In general, you should leave this set to Use Default, which will map all colors to the profile being used on the computer on which the show is playing. If you're certain that a show will be viewed on a particular device, you can use a custom profile.

When you have all your options set, click the Upload button to begin rendering your show and uploading it to the Photodex site (**Figure 8.36**).

Web Shows

To create a Web show, begin by clicking the Create Output button in the toolbar and then choose Web Show, or choose Create > Web. If you haven't saved your show yet, you'll be prompted to do so before you can create the disc. The Create Web Show dialogs in ProShow Gold (**Figure 8.37**) and ProShow Producer (**Figure 8.38**) differ only slightly. ProShow Producer adds a Color tab to the dialog, which lets you set color management options by applying specific profiles for your show.

When you open the dialog, you'll see the Menu tab. In the preview panel, the first slide in your show will appear as a thumbnail, along with the slide's title placeholder. The first step is to change the name to something that suits the show (**Figure 8.39**).

You'll need to decide whether your show is going to use a wide-screen aspect ratio or the standard TV ratio. The decision for which aspect ratio to select should be based on the images you're using in your show. If your photos are in a standard 4:3 dimension, using a wide-screen aspect ratio will leave more empty space on either side of the show and increase the file size.

The Shows tab (**Figure 8.40**) is where you'll add or remove shows from what will become your final online show. To add a show, click the plus (+) button and navigate to the show you want to add. Once you've added the show, you can change the order by using the up and down arrows. The size bar will update, indicating the size of your show on upload.

Figure 8.37 ProShow Gold offers the same output options as ProShow Producer but eliminates the Color tab.

Figure 8.38 ProShow Producer adds options to use color management for your shows.

Figure 8.39 You'll want to give your shows a descriptive name for the main menu screen. Here I've used *Bodie*.

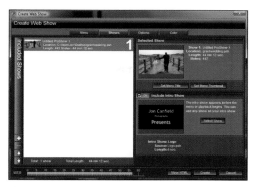

Figure 8.40 On the Shows tab, the size bar updates when you add new content to the show.

Figure 8.41 You can set the thumbnail used on your menu screen from the Shows tab by clicking Set Menu Thumbnail.

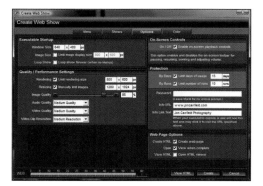

Figure 8.42 The Options tab is where you'll find the login and privacy settings.

For this show, I've added a custom intro show that consists of a single title slide (see Chapter 6 for details on making an intro show).

To change the image used for the menu screen, click Set Menu Thumbnail. This opens the Set Show Thumbnail dialog (**Figure 8.41**), which allows you to select the image you'll see on the menu screen.

You can also change the menu title on the Shows tab by clicking Set Menu Title to open a dialog with an edit field to change the show title.

The Options tab (**Figure 8.42**) is where you'll enter your account information and select which album to store your show in.

On this tab, you'll set the maximum and default sizes for your show, as well as the quality and performance settings. The default size of 640 x 480 is a good choice for playback on most systems. Larger shows will obviously give you more detail in the images but at the expense of larger file sizes and potentially slower playback over some connections.

To keep image size manageable, use the Image Size Rendering and Resizing options in the Quality/Performance Settings area of the dialog. All images will be saved as JPEG format, and you can use the Image Quality slider to control how much compression and detail are retained. The higher settings use less compression and result in a larger file. The default setting of 85 percent is a good option for most images, giving you better performance without sacrificing much detail.

continues on next page

The Audio Quality and Video Quality settings work well for most shows with a Medium Quality setting. If you know that the show will be used only over a high-speed connection, selecting High Quality will improve the viewer experience, but any bandwidth problems will result in delays in both audio and video, resulting in a show that can become out of sync with the slides.

You can add a password to prevent unauthorized viewers from running the show, and you can add information about how to contact you after the executable expires (**Figure 8.43**).

The Create Web Show option can also supply all the HTML needed to view your show online. Select the Create HTML check box to create the page.

As long as you keep the folder structure the same, the Web page you create with ProShow will work without changes. If you need to move files around on your Web server, you'll need to modify the HTML to point to the new location.

The final tab in the Create Web Show dialog (for ProShow Producer) is the Color tab (**Figure 8.44**). This option lets you set a particular color profile. In general, you should leave this set to Use Default, which will map all colors to the profile being used on the computer on which the show is playing. If you're certain that a show will be viewed on a particular device, you can use a custom profile.

When you have all your options set, click the Create button to begin rendering your show. You'll be prompted for a location to save the show. When complete, the rendering will result in two files—an HTML file and a PX file. The HTML file contains the code to run the ProShow Presenter plug-in, and the PX file contains all the show data (**Figure 8.45**).

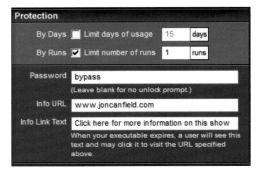

Figure 8.43 ProShow enables you to password-protect your shows and to provide contact information in the form of a URL and text that can be used to contact the author.

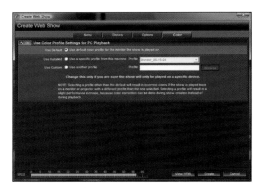

Figure 8.44 You can set specific color profiles for your show on the Color tab (ProShow Producer only) if you know that the show will be viewed on a specific device. Otherwise, it's best to leave this at the default setting.

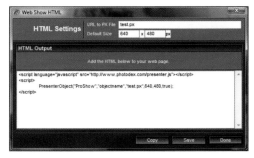

Figure 8.45 ProShow will create an HTML page with the necessary code to run your show on the Web.

CREATING ONLINE SHOWS

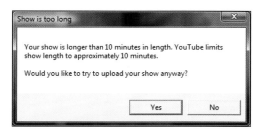

Figure 8.46 If your show exceeds the limits for a YouTube video, you'll see this warning dialog.

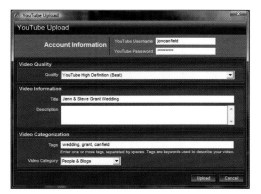

Figure 8.47 ProShow will handle creating and uploading for your show so that it conforms to the YouTube requirements.

Figure 8.48 The title and description of your show will appear along with the thumbnail for the show when viewed on YouTube.

YouTube Shows

To create a YouTube show, begin by clicking the Create Output button in the toolbar and then click YouTube, or choose Create > YouTube. If you haven't saved your show yet, you'll be prompted to do so before you can create the show.

ProShow will check for updates to the YouTube uploading support when the YouTube dialog opens. If your show is longer than ten minutes or bigger than 100 MB, you'll see a "Show is too long" warning dialog (**Figure 8.46**).

Prior to uploading your show, you'll need a YouTube account. If you don't have one, go to www.youtube.com/signup to create an account.

Now, return to ProShow, and enter your account information in the YouTube Upload dialog (**Figure 8.47**).

You have several options for video quality when uploading to YouTube. If you have a wide-screen aspect ratio show, select the YouTube High Definition setting.

In the Video Information area, enter the title and description of the show. Visitors will see this information when they search for your show by title or by keyword (**Figure 8.48**).

To help people find your show online, enter *tags*, which are keywords that can be searched online. You can also add a video category, which will add your show to the items that appear in that category when someone searches by this filter.

Flash Shows

To create a Flash show, begin by clicking the Create Output button in the toolbar and then click Flash, or choose Create > Flash. If you haven't saved your show yet, you'll be prompted to do so before you can create the show.

When the dialog opens, you'll see the Menu tab. In the preview panel, the first slide in your show will appear as a thumbnail, along with the slide's title placeholder. The first step is to change the name to something that suits the show. In **Figure 8.49**, I've changed the name of this show to *Our Day*.

You'll need to decide whether your show is going to use a wide-screen aspect ratio or the standard TV ratio. The decision for which aspect ratio to select should be based on the images you're using in your show. If your photos are in a standard 4:3 dimension, using a wide-screen aspect ratio will leave more empty space on either side of the show and increase the file size.

The Shows tab (**Figure 8.50**) is where you'll add or remove shows from what will become your final Flash show. To add a show, click the plus (+) button and navigate to the one you want to add. Once the show has been added, you can change the order by using the up and down arrows.

You can also select the thumbnail to use for the menu of your show. By default, the thumbnail will use the same image as your first slide. Click Set Menu Thumbnail to select a different slide (**Figure 8.51**).

Figure 8.49 The Menu tab of the Create Flash dialog is where you'll set the menu options for your show.

Figure 8.50 The Shows tab contains the options to add more shows to your Flash project, as well as to select the image that will be used as the thumbnail on the menu.

Figure 8.51 You can change the thumbnail used on your show's menu by clicking Set Menu Thumbnail on the Shows tab.

Figure 8.52 The Options tab is where you'll find the video formatting and size options.

Figure 8.53 ProShow can generate the HTML needed to play your Flash show on the Web.

Figure 8.54 ProShow will display a rendering dialog as your show is created.

For this example, I've also added a custom intro show that consists of a single title slide (see Chapter 6 for details on making an intro show).

The Options tab (**Figure 8.52**) is where you'll set the video, output, and Web options for your show, including the video format and resolution.

The Video Format setting has two options. MPEG4 will give you the best quality, but it requires a newer version of Flash Player. If Flash Player needs to be updated, the user will be prompted to install it when the show plays for the first time.

To keep the playback smooth on a wide variety of systems, set the output resolution to 320 x 240. Larger sizes will require more processing power and a faster connection to keep the show running smoothly.

The setting under Web Page Options control whether ProShow will create a Web page with all the HTML code needed to play your show online. You can view the resulting HTML and make changes as needed (**Figure 8.53**).

When you have all your options set, click the Create button to begin rendering your show and uploading it to the Photodex site (**Figure 8.54**).

Creating Other Types of Shows

You can also create shows that are screen savers or shows for sending in e-mail.

Screen Savers

To create a screen saver, begin by clicking the Create Output button in the toolbar and then click the Screen Saver link in the list of options on the left, or choose Create > Screensaver. If you haven't saved your show yet, you'll be prompted to do so before you can create the screen saver. The Create Screensaver dialogs in ProShow Gold (**Figure 8.55**) and ProShow Producer (**Figure 8.56**) differ only slightly. ProShow Producer adds two tabs to the dialog: Branding, which was covered in Chapter 6, and Color, which lets you set color management options by applying specific profiles for your show.

When the dialog opens, you'll see the Shows tab. In the preview panel, the first slide in your show will appear as a thumbnail, along with the slide's placeholder title. The first step is to change the name to something that suits the show.

You'll need to decide whether your show will use a wide-screen aspect ratio or the standard TV ratio. With an aspect ratio of 16:9, wide-screen is the default, and when shown on a wide-screen computer monitor, the show will fill the screen completely. The 4:3 TV aspect ratio is a better option if you know the show will not be viewed on a standard monitor.

At the lower left of the Create Screensaver dialog, you'll see the size bar letting you know how large your slide show is (**Figure 8.57**).

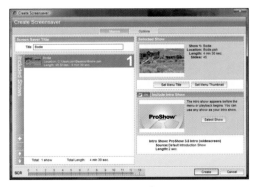

Figure 8.55 ProShow Gold offers the same output options as ProShow Producer but eliminates the Branding and Color tabs.

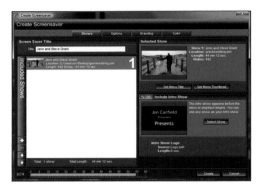

Figure 8.56 ProShow Producer adds options to use color management for your shows and to brand them with a custom startup screen, icon, and status text.

Figure 8.57 The size bar indicates how much space your show will be using.

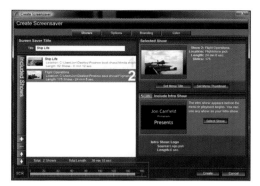

Figure 8.58 The size bar updates when you add new content to the slide show.

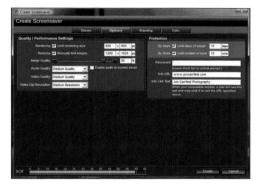

Figure 8.59 On the Options tab, you'll set the quality and performance settings, as well as decide whether to password-protect or limit the number of times the slide show can be played.

Figure 8.60 By limiting the time your show can be viewed, you encourage clients to make their selections early.

You can also add or remove shows from what will become your final screen saver. To add a show, click the plus (+) button and navigate to the show you want to add. Once you've added the show, you can change the order by using the up and down arrows. The size bar will update to show you the amount of space now being used by all content in the slide show (**Figure 8.58**).

For this example, I've also added a custom intro show, which consists of a single title slide (see Chapter 6 for details on making an intro show).

The Options tab (**Figure 8.59**) is where you'll set the quality and format information for your show.

The default size of 800 x 600 is a good choice for playback on most systems. Larger shows will obviously give you more detail in the images but at the expense of larger file sizes and potentially slower playback over some connections.

To keep the image size manageable, set the Image Size Rendering and Resizing options in the Quality/Performance area of the dialog. All images will be saved as JPEG format, and you can use the Image Quality slider to control how much compression and detail are retained. The higher settings use less compression and result in a larger file. The default setting of 85 percent is a good option for most images, giving you better performance without sacrificing much detail.

The Audio Quality and Video Quality settings work well for most shows with a Medium Quality setting.

You can add a password to prevent unauthorized viewers from running the show, and you can add information about how to contact you after the executable expires (**Figure 8.60**).

continues on next page

187

Branding, which was covered in Chapter 6, lets you replace the default Loading Presentation screen with one of your own (**Figure 8.61**). This option is available in ProShow Producer only.

The final tab in the Create Screensaver dialog (for ProShow Producer) is Color (**Figure 8.62**). Color management is a serious concern for professional photographers, but it should be important to everyone. After all, you want your work to look its best regardless of where it's being shown or who is viewing it.

The Color tab allows you to specify what color profile will be used when the show is played back. You can select a profile for video use and one for computer playback. Unless you know that your show will be displayed on the specified devices, though, you're better off leaving these options deselected and defaulting to sRGB, which is typically used by computers and works well with TVs.

To select a specific profile for playback, click the On/Off toggle box to enable the Use Color Profile settings.

Next, select Use Installed if the profile is on your computer, or select Use Custom if you'll be using a profile from another computer or display device (**Figure 8.63**).

The final step in creating your screen saver is to click the Create button. ProShow will prepare all the show content and save the screen saver to your computer.

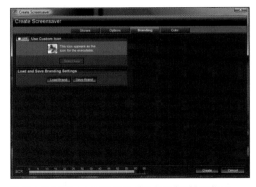

Figure 8.61 You can replace the standard loading screen with one of your own if you're using ProShow Producer.

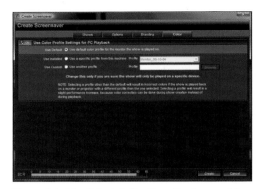

Figure 8.62 The Color tab (ProShow Producer only) lets you select the color profiles to be used when playing your shows.

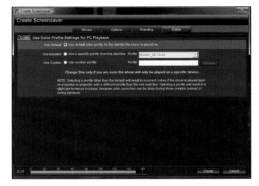

Figure 8.63 If you know that your show will be played on a specific device that has been calibrated, you can use the profile for that device to ensure that colors display accurately.

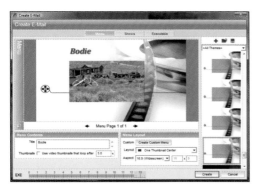

Figure 8.64 ProShow Gold offers the same output options as ProShow Producer but eliminates the Branding and Color tabs.

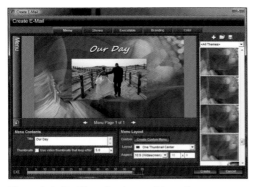

Figure 8.65 ProShow Producer adds options to use color management for your shows and to brand them with a custom startup screen, icon, and status text.

Figure 8.66 The Menu tab of the Create E-Mail dialog is where you'll set the menu options for your show. I've used *USS Nimitz* here.

Figure 8.67 The size bar indicates how much space your show will be using.

E-mail Shows

To create an e-mail show, begin by clicking the Create Output button in the toolbar and then click the E-Mail link in the list of options on the left, or choose Create > E-Mail. If you haven't saved your show yet, you'll be prompted to do so before you can create the e-mail. The Create E-Mail dialogs in ProShow Gold (**Figure 8.64**) and ProShow Producer (**Figure 8.65**) differ only slightly. Producer adds two tabs to the dialog: Branding, which was covered in Chapter 6, and Color, which lets you set color management options by applying specific profiles for your show.

When the dialog opens, you'll see the Menu tab. In the preview panel, the first slide in your show will appear as a thumbnail, along with the slide's placeholder title. The first step is to change the name to something that suits the show (**Figure 8.66**).

You'll need to decide whether your show will use a wide-screen aspect ratio or the standard TV ratio. The decision for which aspect ratio to select should be based on the images you're using in your show. If your photos are in a standard 4:3 dimension, using a wide-screen aspect ratio will leave more empty space on either side of the show and increase the file size.

The Shows tab is where you'll add shows and set other options for your e-mail show.

At the lower left of the Create E-Mail dialog, you'll see the size bar letting you know how large your slide show is (**Figure 8.67**).

You can also add or remove shows from what will become your final e-mail show. To add a show, click the plus (+) button and navigate to the show you want to add. Once you've added the show, you can change the order by using the up and down arrows. The size bar

continues on next page

CREATING OTHER TYPES OF SHOWS

will update to show you the amount of space now being used by all content in the e-mail show (**Figure 8.68**).

For this show, I've also added a custom intro show that consists of a single title slide (see Chapter 6 for details on making an intro show).

The Executable tab (**Figure 8.69**) is where you'll set the quality and format information for your show.

The default size of 800 x 600 is a good choice for playback on most systems. Larger shows will obviously give you more detail in the images but at the expense of larger file sizes and potentially slower playback over some connections.

To manage the size of your images, set the Rendering and Resizing options under Quality/Performance Settings to the maximum size you want to use. All images will be saved as JPEG format, and you can use the Image Quality slider to control how much compression and detail are retained. The higher settings use less compression and result in a larger file. The default setting of 85 percent is a good option for most images, giving you better performance without sacrificing much detail.

The Audio Quality and Video Quality settings work well for most shows with a Medium Quality setting.

You can add a password to prevent unauthorized viewers from running the show, and you can add information about how to contact you after the executable expires (**Figure 8.70**).

Branding, which was covered in Chapter 6, lets you replace the default Loading Presentation screen with one of your own (**Figure 8.71**). This option is available in ProShow Producer only.

Figure 8.68 The size bar updates when you add new content to the slide show.

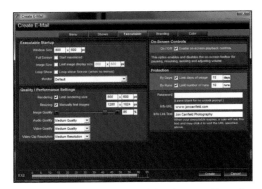

Figure 8.69 The Executable tab is where you'll set the quality and performance settings, as well as decide whether to password-protect or limit the number of times a viewer can play the e-mail show.

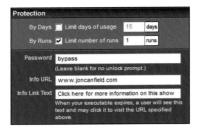

Figure 8.70 By limiting the time your show can be viewed, you encourage clients to make their selections early.

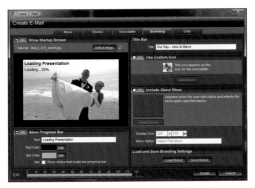

Figure 8.71 You can replace the standard loading screen with one of your own if you're using ProShow Producer.

Figure 8.72 The Color tab (ProShow Producer only) lets you select the color profiles to be used when playing your shows.

Figure 8.73 ProShow will create an e-mail message with your show attached when you click Create. You can add recipients and a personal message before sending the show.

The final tab in the Create E-Mail dialog (for ProShow Producer) is Color (**Figure 8.72**). Color management is a serious concern for professional photographers, but it should be important to everyone. After all, you want your work to look its best regardless of where it's being shown or who is watching.

The Color tab allows you to specify what color profile will be used when the show is played back. You can select a profile for video use and one for computer playback. Unless you know that your show will be displayed on the specified devices, however, you're better off leaving these options deselected and defaulting to sRGB, which is typically used by computers and works well with TVs.

To select a specific profile for playback, click the Off/On toggle box to enable the Use Color Profile settings.

Next, select Use Installed if the profile is on your computer, or select Use Custom if you'll be using a profile from another computer or display device. The final step in creating your e-mail show is to click the Create button. ProShow will prepare all the show content and create the executable file for the show. You'll have the opportunity to watch the show, as well as create an e-mail message to send with the show attached (**Figure 8.73**). Once you provide the address to send the e-mail to, ProShow will upload and send your mail.

Creating Shows for Devices

ProShow supports a number of devices, notably all the major entertainment systems—Microsoft Xbox 360, Nintendo Wii, and Sony PlayStation 3 and Portable. This support also covers media players, such as the Apple iPod, and cell phones, including the Apple iPhone, BlackBerry devices, Nokia phones, and Palm phones. You can even generate shows for the Apple TV and TiVo DVR.

To create a show for one of these devices, click the Create Output button and choose Device, or choose Create > Devices (**Figure 8.74**).

Choose from the list of available devices. Your only options in the Create Video for Device dialog are to set the location in which to save the show and to set the quality. By default, ProShow will save to one of your removable media drives, letting you save the file directly to a memory card that you can insert into the device. You can also set the location to save the show to by selecting "Choose a specific location" from the Save Location drop-down menu.

If your device isn't listed, you can add a new one by clicking the Add button below the list of devices (**Figure 8.75**).

In the Custom Device Video Output dialog (**Figure 8.76**), enter the information for your device. You'll need to know what video and audio formats your device supports, as well as the display resolution to have your shows play properly. You can have multiple profiles for each device, each with different quality settings for playback.

✔ Tip

■ You can find information on resolution, file formats, and frame rates in the owner's manual for your device or online at the manufacturer's Web site.

Figure 8.74 ProShow enables you to create shows for a number of devices, including cell phones, entertainment systems, and media players.

Figure 8.75 It's easy to add devices to ProShow with the Add button. You'll be prompted to select the type of device you're configuring.

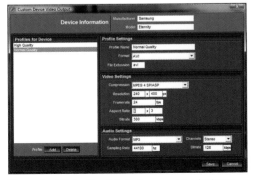

Figure 8.76 Enter the details for your new device to tell ProShow what size, quality, and format to create your show in for proper playback.

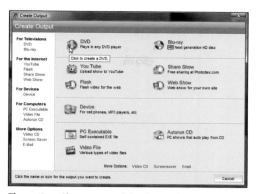

Figure 8.77 Choose one of the Create Output options to access the protection features common to ProShow Gold and ProShow Producer.

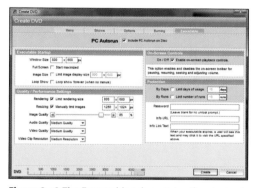

Figure 8.78 The Executable tab contains the playback quality and protection options.

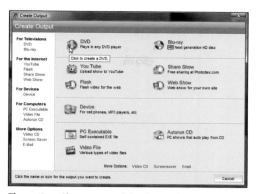

Figure 8.79 In this example, I've set the show to expire after 15 days or 10 runs, whichever comes first.

Protecting Your Work

Both ProShow Gold and ProShow Producer include features to help you keep your shows from unauthorized viewing or use. ProShow Producer adds copy protection to the tools you have available to you to further protect your valuable work.

Adding Basic Protection

In both ProShow Gold and ProShow Producer, you can protect your shows by requiring passwords and by limiting the number of times or days your show can run.

To protect your show, choose any of the Create options. In this example, I'll create a DVD.

Click Create Output, and click DVD (**Figure 8.77**). If you haven't saved your show yet, you'll be prompted to do so before continuing.

In the Create DVD dialog, choose the Executable tab (**Figure 8.78**). Along with all the options to control the show's playback size and quality, you'll see a set of options labeled Protection.

In the Protection options, you can limit the number of times your show can be run by setting either the number of days or the number of times it can be viewed. You can also set both options. In the example shown in **Figure 8.79**, I've limited the show to 15 days or 10 runs. Whichever limit is reached first will cause the show to quit playing.

continues on next page

By including a password (**Figure 8.80**), you require your viewers to enter that password to view the show. Leaving this field blank lets anyone view the show within the allotted time period or number of views. If you're placing shows online for clients to view, password-protecting them is a good way to prevent unauthorized viewing of the show.

Finally, you can include an informational URL and help text that will display when someone tries to run the show after it has expired. If you're protecting your shows, this is a good option to select, because it gives people a way to easily find more information about you and the show.

When a password-protected show is run, a dialog appears requesting activation information (**Figure 8.81**). If the user provides a password, the show will be unlocked, removing viewing restrictions from the show.

If you don't provide a password, when the show expires, the viewer will have the option to enter a password or click the link to contact you (**Figure 8.82**).

With no password, the show will run for the specified number of days or times before displaying a dialog letting the viewers know the show has expired and providing a link for them to contact you (**Figure 8.83**).

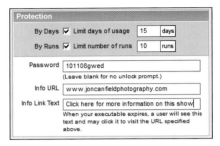

Figure 8.80 Including a password gives you more security over unauthorized viewing. If you're placing private shows on a Web site, this is a good option.

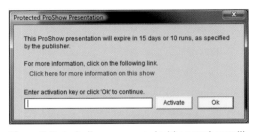

Figure 8.81 Including a password with your show will display this dialog. If the viewer enters a password, all restrictions are removed.

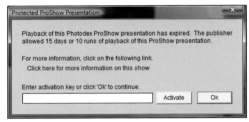

Figure 8.82 After a show has expired, viewers can either provide a password to unlock it or contact you via the information you provided when protecting the show.

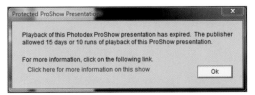

Figure 8.83 If no password protection was applied, the viewers will see this dialog when the show expires.

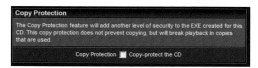

Figure 8.84 You can copy-protect autorun CDs in ProShow Producer by enabling the option on the Burning tab.

Figure 8.85 Create a new document in Photoshop or another image editor for your logo file. Use a transparent background for a cleaner watermark.

Adding Copy Protection

ProShow Producer adds the ability to copy-protect your CDs. This function is not available for DVD or Blu-ray discs. To add copy protection to a CD, click Create Output and then Autorun CD. On the Burning tab, you'll find the Copy Protection option (**Figure 8.84**). To enable copy protection, click the check box to activate the feature.

Applying Watermarks

Another method of protecting your work is to add watermarks to each of your slides. ProShow Producer makes this easy to do with the Use Watermark Image option.

To create a watermark, you'll need to use a separate image-editing program such as Adobe Photoshop. Create your watermark at 72 dpi, and save it as a PNG file.

I create a new document with the dimensions of 300 x 100 and a transparent background (**Figure 8.85**). Next, I use the Text tool to enter my logo text, and then I save the document as a PNG file to preserve the transparent background (JPEG does not support transparency and will render the image with the background color when you save the document).

With the file saved, open the Show Options dialog in Producer. Switch to the Watermark tab of the Show category, and select the On/Off toggle box for Use Watermark.

continues on next page

PROTECTING YOUR WORK

Click Browse, navigate to the location where you saved your watermark file, and select it. The watermark will be displayed in the Preview panel (**Figure 8.86**).

You can adjust the opacity and other elements of the watermark in the same way as you would adjust a regular image (see Chapter 5 for full details on image adjustments).

Finally, size and position the watermark where you want it to appear on the slides in your show. I typically use the lower-right corner for my watermarks, but they can be positioned anywhere on the slide (**Figure 8.87**).

When your show is played, the watermark will appear on every slide that does not use a custom background, such as menus (**Figure 8.88**).

✔ Tip

- Watermarks should be simple in order to avoid competing with your presentation. The goal is to have your watermark visible but not the star of the show. I use a simple name and URL for my watermarks.

Figure 8.86 Add the watermark in the Show Options dialog. This will appear on every slide in your show that doesn't use a custom background.

Figure 8.87 Size and position your watermark (shown here in the lower-right corner) on the slide by dragging the selection handles.

Figure 8.88 The watermark will be displayed on your images in the selected location, adding more protection against unauthorized copying.

KEYBOARD SHORTCUTS

You'll find all the ProShow keyboard short-cuts here. Shortcuts are arranged by areas to make them easier to find.

Menus

File menu	Alt+F
Edit menu	Alt+E
Project menu	Alt+P
Show menu	Alt+S
Slide menu	Alt+L
Audio menu	Alt+A
Create menu	Alt+C
Window menu	Alt+W
Help menu	Alt+H

User Interface

Help	F1
Slide List/Timeline toggle	Tab
Default Window Layout	Ctrl+Shift+Alt+0
Thumbnail File List View	Alt+8
Detail File List View	Alt+9
Hide/Show Favorites	F9
Hide/Show Preview	F8
Hide/Show Project Pane	F11
Hide/Show Lightbox View	F7
Create Output	Alt+0
Exit	Alt+X

Toolbar

New	Ctrl+N
Open	Ctrl+O
Save	Ctrl+S
Play	Spacebar
Options	F2
Slide	Ctrl+Enter
Timeline/Slide List	Tab
Slides	Ctrl+F1
Layers	Ctrl+F4
Effects	Ctrl+F7
Captions	Ctrl+F9
Music	F6
Create output	Alt+0

Files

Jump to File	First letter of filename
Select All	Ctrl+A
Select None	Ctrl+Alt+A
Select Inverse	Ctrl+I

Shows

New Show	Ctrl+N
Open Show	Ctrl+O
Save Show	Ctrl+S
Save Show As	Ctrl+Shift+S
Close Show	Ctrl+W
Show – Settings	F2
Show – Background	F3
Show – Watermark	F4
Show – Captions	F5
Show – Soundtrack	F6

KEYBOARD SHORTCUTS

Slides

Undo	Ctrl+Z
Redo	Ctrl+Y
Cut	Ctrl+X
Copy	Ctrl+C
Paste	Ctrl+V
Paste Into	Ctrl+Shift+V
Select All Slides	Ctrl+A
Select None	Ctrl+Alt+A
Add Selected Files to Show	Ctrl+Shift+A
Add All Files to Show	Ctrl+Shift+Alt+A
Select Inverse	Ctrl+I
Slide Options	Ctrl+L
Slide Options	Ctrl+Enter
Move Slide Left	<
Move Slide Right	>
Go To Slide	Ctrl+G
Insert Blank Slide	Alt+I
Insert Title Slide	Alt+T
Fill Frame	Alt+0
Fit to Frame	Alt+1
Fill Safe Zone	Alt+2
Fit to Safe Zone	Alt+3
Stretch to Frame	Alt+4
Delete Slide	Delete
Slide List/Timeline toggle	Tab
Randomize Slide Order	Ctrl+Shift+1
Randomize Slide Motion	Ctrl+Shift+2
Randomize Transitions	Ctrl+Shift+3
Change Layer (1–10)	Ctrl+1...Ctrl+0
Slide Styles	Ctrl+F1
Slide Settings	Ctrl+F2
Slide – Background	Ctrl+F3
Slide – Layers	Ctrl+F4
Slide – Video	Ctrl+F5
Slide – Editing	Ctrl+F6
Slide – Motion Effects	Ctrl+F7
Slide – Adjustment Effects	Ctrl+F8
Slide – Captions	Ctrl+F9
Slide – Caption Motion	Ctrl+F11
Slide – Sound Effects	Ctrl+F12

Audio

Show – Soundtrack	F6
Manage Soundtrack	F6
Sync Slides to Audio	Ctrl+T
Quick Sync – Entire Show	Ctrl+Q
Quick Sync – Selected Slides	Ctrl+Shift+Q
Quick Sync – Selected Slides to Track	Alt+Q

Playback

Play/Pause	Spacebar
Stop	Escape

Executable Playback

Select Show	# of show
Return to Menu	Escape or Home
Exit	Escape (From menu)
Toggle Full Screen	Alt+Enter
Next Slide	Page Down
Previous Slide	Page Up
Pause/Resume	Spacebar
Resume	Enter

KEYBOARD SHORTCUTS

199

ProShow Lightroom Plug-in

Although ProShow has a very capable file browser, if you're a user of Adobe Photoshop Lightroom, it's worth looking into the free ProShow plug-in for Lightroom that is available from Photodex.

With the ProShow plug-in, you can export your images directly from Lightroom into ProShow with the timing, transitions, and more already set for you. For the busy studio photographer in particular, it's a quick way to get your images in front of the client directly from your image-editing program, and for everyone else, it's a nice way to get a head start with a new show.

The plug-in is not included with the download of ProShow Gold or Producer, so you'll need to go to the Photodex Web site (*www. photodex.com/downloads/go_lrplugin*) to install it. And, although Lightroom is Mac and Windows compatible, the plug-in, like ProShow, is Windows only.

Using the Plug-In

Once you've downloaded the plug-in, run the setup program (**Figure B.1**). The installer will automatically select the correct location for the plug-in. If Lightroom is already running, exit and restart the program before continuing.

In Lightroom, select the images you want to use in your slide show, and choose File > Export to open the Export dialog (**Figure B.2**).

Several presets are included with the plug-in:

◆ Framed Show, which adds a border layer to each slide

◆ High Energy Show, which uses a short duration and transition time for faster playback

◆ Proofing Show, which includes slide numbers as captions to assist with image ordering

◆ Standard Show, which is essentially the default settings in ProShow for a new, blank show

◆ Widescreen Show, which is the same as Standard Show but uses a 16:9 aspect ratio for slides

The show options are divided into several groups. We'll take a look at each of these groups individually. As we go through these options, remember that the presets are just that—preset starting points that you can modify to fit your needs.

Figure B.1 Run the setup program after downloading the plug-in from the Photodex Web site.

Figure B.2 You access the ProShow plug-in through the Export dialog in Lightroom.

Figure B.3 Slide Options includes settings found in the Slide List for timing and transitions and in the Slide Options dialog for layers and motion.

Figure B.4 Captions and Copyrights from Metadata can read information from your images and place that data on your slides.

Slide Options

The Slide Options settings (**Figure B.3**) contain many of the settings you'd find in the ProShow Slide List and the Slide Options dialog.

In this set of controls, you can adjust the slide and transition timing as well as select from any of the transitions available in ProShow.

Motion Effects gives you control over panning, zooming, and rotation of photos via slider controls.

Photo Border will add a layer to your slides with one of a number of different border effects, such as a simple color border or a grunge border for an edgy look to your images. Finally, the Shadow check box controls whether a drop shadow is placed on your images.

You can fine-tune these settings after exporting your slides to ProShow from within the Slide Options dialog.

Captions and Copyrights from Metadata

The Captions and Copyrights from Metadata options (**Figure B.4**) determine whether ProShow will use the Photo Title, Photo Description, and Photo Copyright text from the metadata included with your image.

When the images are exported from Lightroom into ProShow, the information in these metadata fields will be copied with the image and placed on the slide.

Along with controlling what text is copied, you can select the text color, size, and location, as well as set motion effects. You can further these options in ProShow in the Slide Options dialog on the Captions tab.

Proofing Show Captions

The Proofing Show Captions (**Figure B.5**) settings allow you to display information about your images to help viewers choose photos for purchase or print.

The options here are whether to show the slide number and whether the photo name will be shown. Like the Captions and Copyrights from Metadata options, you have control over text color, size, and placement, along with motion effects.

You can further adjust these settings in ProShow on the Slide Options dialog's Captions tab or on the Show Options Captions tab.

Show Options

Show Options (**Figure B.6**) has settings for the show title, aspect ratio, and background color.

You can set the aspect ratio either to 4:3 for standard television or to 16:9 for wide-screen display.

You can also find these options in the Create Output options in ProShow.

Export Location

The Export Location settings (**Figure B.7**) let you select where your show will be exported.

You can select whether to export to a new folder and choose which folder that will be, or you can export to the current folder to keep all your files in one location. Additionally, you can select whether to place the exported files into a subfolder.

The Add to This Catalog and Stack with Original check boxes determine whether your exported images will be included in the Lightroom catalog after exporting. If you choose these options, the new files will be added to the catalog and stacked with the original file to make it easier to locate them.

Figure B.5 The Proofing Show Captions options are useful when you need to show slide numbers or photo titles to viewers.

Figure B.6 Show Options is where you set the show title, aspect ratio, and background colors.

Figure B.7 The Export Location settings control where your exported files are placed.

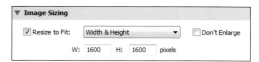

Figure B.8 Image Sizing lets you determine how your images are resized when exported to ProShow.

Figure B.9 The ProShow Configuration settings are where you'll specify what format show you want to export and where ProShow is located on your computer to complete the process.

The final option in this group of settings is what to do with existing files. You can have the plug-in ask you what to do, overwrite the files, skip existing files, or choose a new name for duplicate files.

Image Sizing

Image Sizing (**Figure B.8**) controls how the images are sized during export.

You can select whether you want Lightroom to resize the image when your images are exported for use in ProShow. Options are to leave images at the current size, resize the width and height, resize to fit either the long or short edge, and resize to fit specific dimensions.

You can also tell the plug-in not to enlarge images if they are smaller than the requested dimensions.

ProShow Configuration

ProShow Configuration (**Figure B.9**) is where you'll tell the plug-in how to find ProShow (which must be installed in order to use the plug-in) and what format to export the show as.

By default, the plug-in will specify the normal installation location for ProShow. If you've installed to a different location or you have multiple copies of ProShow installed—for example, both Gold and Producer—you can use the Browse button to navigate to the folder containing the version of ProShow you want to use for exporting.

Show Format lets you specify whether to export as a ProShow Gold or ProShow Producer format show. Finally, the Get ProShow button is there to give you a quick and easy way to purchase the program after you've seen how quickly and easily you can create a professional show.

✔ Tip

■ If you've made changes to the settings in the plug-in that you'd like to reuse, you can create your own preset. In the Export dialog, just click the Add button below the Preset list to create a new preset for future use.

Creating Your Show

With your options selected in the Export dialog, the final step is to click Export. This will dismiss the plug-in dialog, and Lightroom will export the selected images to the specified location. Once the export is complete, ProShow will launch with the new show loaded (**Figure B.10**).

From this point, you can make further modifications to your show, including adding music or more advanced motion effects with keyframes and adding titles.

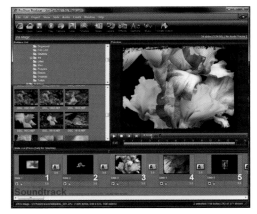

Figure B.10 ProShow will launch after the files have been exported, with your show loaded and ready for viewing or more editing.

INDEX

INDEX